IMAGES
of America

GREENCASTLE-ANTRIM

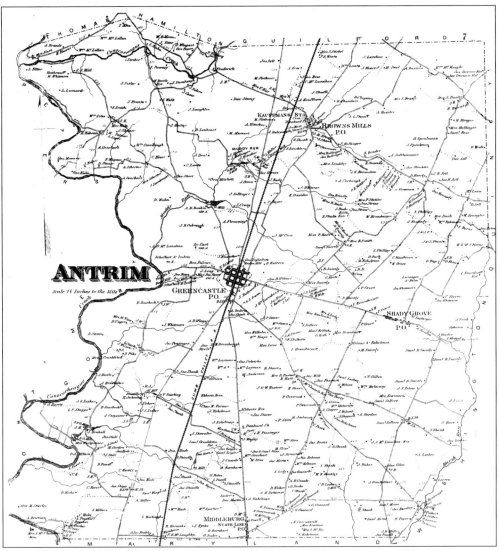

When this map was made in 1868, Antrim Township, the oldest township in Franklin County, was 127 years old. At that time, Antrim's western border went only as far as the Conococheague Creek. Antrim was still being used to create new townships in the county. Eventually, it regained the portion of land west of the creek. The outlying villages with post offices were Shady Grove, State Line, and Brown's Mill, which would not be changed to Kauffman's Station until 1889. All the gristmills and sawmills were operating and servicing the farmers in their areas. Traveling on the 28-year-old Waynesboro-Greencastle-Mercersburg Turnpike, one rode across the five-arch limestone bridge that crossed the Conococheague. It was 35 more years until the initial line of the county's first mass-transit system, the trolley, was in operation between Greencastle and Shady Grove. (Courtesy of the Lilian S. Besore Memorial Library.)

IMAGES
of America

GREENCASTLE-ANTRIM

Bonnie A. Shockey and Kenneth B. Shockey
with the Allison-Antrim Museum

ARCADIA

First published 2004
Reprinted 2004

Published by Arcadia Publishing,
Charleston SC, Chicago IL, Portsmouth NH, San Francisco CA

Printed in Great Britain

Library of Congress Catalog Card Number: 2004100862

For all general information, contact Arcadia Publishing:
Telephone 843-853-2070
Fax 843-853-0044
E-mail sales@arcadiapublishing.com
For customer service and orders:
Toll-free 1-888-313-2665

Visit us on the Internet at www.arcadiapublishing.com

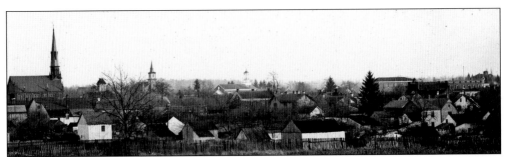

Shown here is Greencastle's skyline c. 1895. The Evangelical Lutheran Church appears on the left, beside the engine house (with cupola), built in 1887. The next steeples belong to the United Methodist Church and the Grace United Church of Christ. Next to the large pine tree is town hall. The Brendle Building did not appear until 1914. This image is from a George F. Ziegler glass-plate negative. (Courtesy of the Allison-Antrim Museum.)

Just a note...

10531NP

CONTENTS

ACKNOWLEDGMENTS

The task of compiling this book would not have been possible without the help of many people from across the country who loaned or donated their photographs or helped in some other way with the book's organization. However, a small committee was responsible for the completion of this book. Jane C. Alexander proofread, and Ted Alexander wrote the back cover text and edited the introduction. Isabelle Barnes, Pete Goetz, and Louise Mowen researched and helped with identification. My husband, Ken, equaled my number of hours by providing technical assistance in scanning images, laying out pages, and making "house calls" with his scanner and laptop computer. All the names of those who loaned photographs for the book are given in courtesy lines at the end of the captions.

It has been a great honor to be an author of Images of America: *Greencastle-Antrim*, and it has also been an amazing journey through the history of Antrim Township and Greencastle. I have stepped back into our yesterdays, when the people who are now gone were still alive and places were familiar yet different, and have turned around to find myself in the present with a greater understanding of today's Greencastle-Antrim.

One of the primary goals at the Allison-Antrim Museum is to help each visitor, young or old, connect our yesterday to our today and our tomorrow. That connection can be found in artifacts and archives, but the connection does not just lie in the object itself. The true connection is in the story that each piece has to share.

Through the images that many individuals captured for posterity, I am confident that this book will be another bridge that will connect our yesterday to our today and our tomorrow. Some of the earliest images were drawn or painted. With the advent of the camera, the likenesses of many more places and people were able to be captured for all time. Little did the photographers know that what their eyes saw when they looked through the lens would make a difference 50 years, 100 years, or more later in the lives of their descendants and others who followed them in Greencastle-Antrim.

As you begin to leaf through this book of images from our past, imagine yourself as one of your ancestors—a great-grandmother or great-grandfather or even farther back—walking the countryside, clearing land for a homestead, or standing behind the counter of a retail business. What hardships did these people encounter in their daily lives, and who were their neighbors? How did they travel? Imagine yourself in the photograph, in front of the camera when the picture was taken. Godspeed to you on your way.

—Bonnie A. Shockey
President, the Allison-Antrim Museum

INTRODUCTION

American Indians were the first inhabitants of the area now known as Greencastle-Antrim, which is located in the south-central part of Franklin County in the heart of the Cumberland Valley. This area, with its lush grassy meadows, forested lands, springs, and the Conococheague Creek, provided ideal hunting and fishing grounds for the nomadic peoples. Evidence of their camps has been found around the springs that are on many of the first homesteads of the area. Today, archaeologists are unearthing numerous American Indian artifacts, used many centuries ago, including arrowheads, cutting implements, shards of vessels, and sharpening tools. The Delaware Indians often traveled through this area while hunting and fishing. Evidence of a Shawnee village has been found northeast of Greencastle near Shady Grove. Another village was also found about a mile north of the Mason-Dixon Line along the east branch of the Conococheague. A Seneca village was located at the confluence of the east and west branches of the Conococheague.

The first white men to settle the area were the Ulster-Scots (Scots-Irish). These Lowland Scottish Presbyterians settled in the north of Ireland in the 1600s under the encouragement of King James I as a bulwark against Irish Catholicism. By the 1720s, political, religious, and economic unrest forced them to seek a better life in the New World. The Scots-Irish, who immigrated to Pennsylvania in the early Colonial days, were very influential in the forming of Pennsylvania. Some familiar Greencastle-Antrim Scots-Irish surnames are Allison, Irwin, Craig, McLaughlin, McLanahan, McDonald, McDowell, McCrae, Chambers, and Davison.

The descendants of the Lowland Scots who settled this area were robust, adventurous, and rebellious. There is no architectural style or type of furniture attributed to them, and there are few known artifacts surviving that are specific to the Scots-Irish. Two of the artifacts that *are* known are communion tokens and thistle biscuit stamps. The thistle is the national flower of Scotland, and the dwarf thistle grows freely in the fields of Pennsylvania.

The prevailing legacy of the Scots-Irish is their religion. In each settlement, they built a church in which to practice their Presbyterian faith. In the early 1700s, this area's settlement was known as the East Conococheague Settlement. The first church was built at Moss Spring in 1737. It was a log structure that was located just a few blocks northeast of Greencastle's square.

Like the American Indians, the Scots-Irish were nomadic. Many of those who settled Greencastle-Antrim and other parts of the Cumberland Valley moved south into the Shenandoah Valley of Virginia and other parts of the southeast. Education was one of the highest priorities of the Scots-Irish, and they were the first to establish schools in their communities. The Scots-Irish utilized the Scandinavian-style housing of log cabins. Their diet consisted mostly of pork, corn, and mutton. Their music, another part of their legacy, was played on fiddles and dulcimers.

Jacob Snively was probably the first white settler in Antrim Township. He arrived in 1731 and purchased a total of 1,500 acres of land in 1734 and 1735. The land was situated approximately two miles northeast of Greencastle. In 1734, Joseph Crunkleton received from the Penn family a license for an unspecified number of acres located about two miles east of Greencastle, where Shady Grove is today. At a later date, it was surveyed and patented. James Johnston settled on land that was situated two and one-half miles east of Greencastle c. 1735. That same year, James Rody settled along the Conococheague Creek about one mile west of Greencastle. These four homesteads comprised the first white settlement in Antrim Township, which became known as the Conococheague Settlement.

The Germans followed shortly after the Scots-Irish, eventually dotting the valley with bank barns, which are unique architectural features of this area. The Pennsylvania Germans were primarily of the Lutheran and Reformed faiths. In the beginning, more often than not, the two denominations shared the same building—a union church—in which they both worshiped. This partnership worked because their doctrines were similar and the number of ministers was few compared to the geographical area that they served. Union churches were built in each community; communities were anywhere from five to eight miles distance from each other. The ministers would alternate Sundays at each of the churches, thereby assuring a church service every Sunday for the parishioners. Other sects were Plain People. These included the Mennonites and Brethren (Dunkards). Many of these denominations held services in the German language into the 20th century.

Antrim Township, established in 1741 at the May Quarter Sessions Court of Lancaster County, is named after County Antrim in the very northeast corner of Northern Ireland from whence many of the area's first settlers came. There is also a town by the name of Antrim located in County Antrim. The land that Greencastle now sits upon was first deeded to Samuel Smith by a land warrant in 1750. It was eventually sold to William Allison Sr. in 1763, who transferred 300 acres to his son John in 1769.

John Allison was a colonel in the Revolutionary War and served three terms in the Pennsylvania Assembly. He founded Greencastle in 1782, aided by James Crawford, who laid out the town in 246 numbered lots of equal size (30 feet wide by 250 feet long). The lots were then sold through a lottery at $8 each.

If Greencastle was named for a place in the north of Ireland, then the gently rolling landscape of the area, very much like that of the settlers' former homeland, was probably a deciding factor in choosing the name.

One
ANTRIM TOWNSHIP

The East Conococheague Creek (*Conococheague*, an American Indian word meaning "a long way, indeed") flows through Antrim Township and is joined by the west branch near Worleytown. Continuing southward, it empties into the Potomac River at Williamsport, Maryland. The Conococheague, the springs and streams that feed it, and the rich fertile land and forests through which it flows drew American Indians to this area thousands of years before the first white man. (Courtesy of Nate Bacon.)

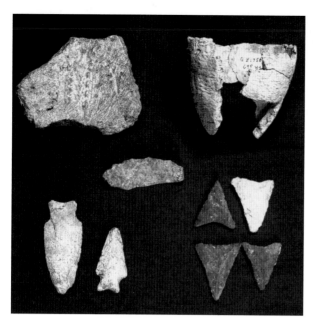

Evidence that Seneca and Shawnee Indians regularly migrated through Antrim Township, and sometimes established villages, has been unearthed by farmers and archaeologists. Some of the American Indian artifacts (c. 6000 BC–AD 1400) that have been discovered at Ebbert Spring are shown here. From left to right are the following: (bottom) two atlatl points, a sharpening instrument, and four arrowheads; (top) a carved soapstone bowl and a partial pottery vessel. (Courtesy of Cumberland Valley Chapter 27 of the Society of Pennsylvania Archaeology.)

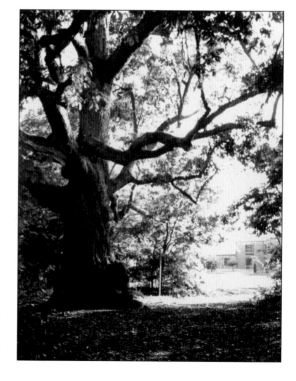

The chinquapin oak tree at the Tayamentasachta Environmental Center is more than 350 years old, making it one of the oldest of its species on the east coast. It is 84 feet tall with a 90-foot crown. It takes nine first-graders holding hands to encircle its 16-foot-10-inch circumference. Throughout the centuries, the chinquapin has welcomed an untold number of people to sit beneath its shade. (Courtesy of Jodi Plum.)

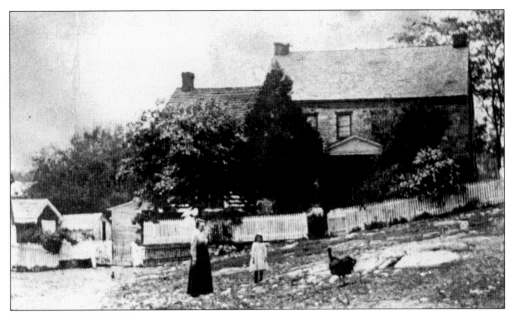

Jacob Snively, Joseph Crunkleton, James Johnston, and James Rody purchased land located in Antrim Township in 1734 and 1735. Their four homesteads comprised what became known as the Conococheague Settlement. James Johnston Sr. built this home at 11404 Stull Road, which was inherited by his son Col. James Johnston Jr. During the Revolutionary War, Colonel Johnston commanded a battalion of local county men. (Courtesy of Louise Stull.)

Moss Spring provided the site for the first church structure built in the county by the Scots-Irish Presbyterian settlers c. 1737. That log structure, which burned during the French and Indian War, was replaced c. 1767 with a weatherboard building known as the Red Church. Rev. Samuel Cavin served as the first minister. To this day, the spring provides an ample supply of clear, cold, fresh water. (Courtesy of the Allison-Antrim Museum.)

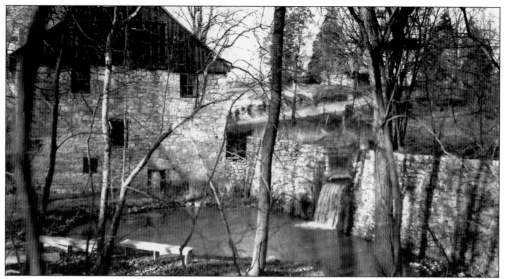

The Kiesecker-Shinham Mill was the earliest gristmill mentioned in local records. Existing before 1747, it was powered by the waters of Muddy Run and was located at the intersection of Shinham and Frank Roads. It was not only the first mill in the area but also the last to survive. It was torn down in 1970. (Courtesy of Lloyd "Sonny" Rowe.)

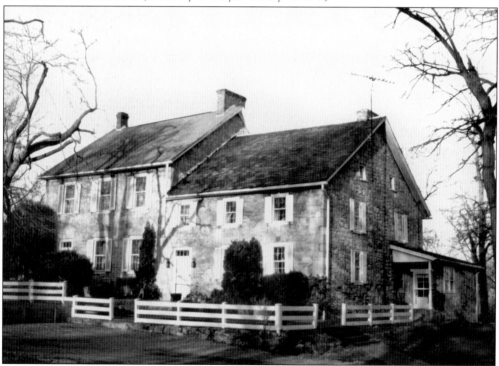

In 1750, a land warrant for 270 acres was issued to William Allison Sr. in Antrim Township. At 12633 Molly Pitcher Highway, near Ebbert Spring, he built a limestone home (lower section) with walls almost three-feet thick. A stockade was built over a section of the spring in the event of an American Indian attack. The higher portion of the house was built in the 1800s. (Courtesy of Kenneth Shockey.)

Thomas Poe obtained a land warrant for 368 acres in 1750. On that land, he built the two-story section of this limestone house at 6169 Guitner Road. His son James played hooky from school the day of the Enoch Brown Massacre, thereby preserving his life. James, as a grown man, acquired the property, at which time he added the lower portion of the house. James Poe married Elizabeth, a daughter of Gen. James Potter. In April 1758, American Indian Delawares attacked the house while the Poes had visitors. One man was killed, and Richard Bard and his wife, Katherine, were captured. Richard escaped a short time later, and after two and one-half years of negotiating, Katherine Bard was released. General Potter spent the end of his life with his daughter in the Poe house. He was also the grandfather of Andrew G. Curtin, the governor of Pennsylvania during the Civil War. The west side of this property (opposite of this view) was actually the front of the house, facing the Conococheague. (Courtesy of Glen Cump.)

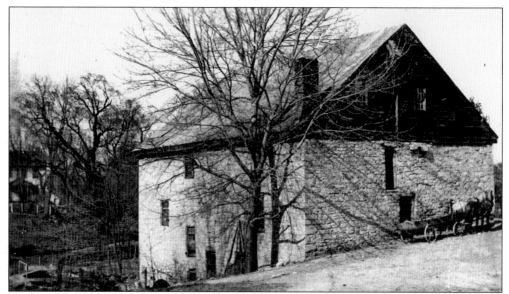

Rankin's Mill was built *c.* 1754 by Jeremiah Rankin and was located where Muddy Run (which provided the power) crosses Williamson Road, about a mile west of Route 16. On Sunday morning, July 8, 1756, American Indians attacked, killing Caspar Walter, the owner, and taking four of his children captive. The children were released after eight years, only recognizing their mother by a song she used to sing to them. (Courtesy of Frank Ervin.)

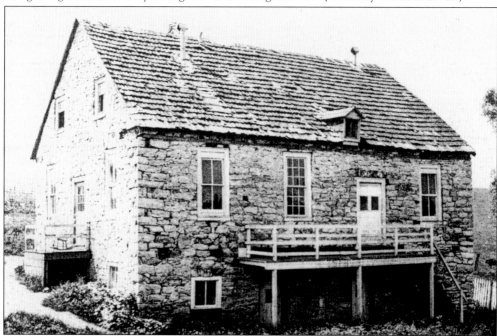

Two houses that were built in the Conococheague Settlement were used by the area's early settlers for protection during the French and Indian War and the Pontiac Rebellion. Built *c.* 1755 by William Allison Sr., this home was located at McCauley Spring, which is several hundred yards southwest of the intersection of Routes 16 and 11. Tradition says that during the Civil War, this structure was also used to hide runaway slaves. (Courtesy of Doug Stine.)

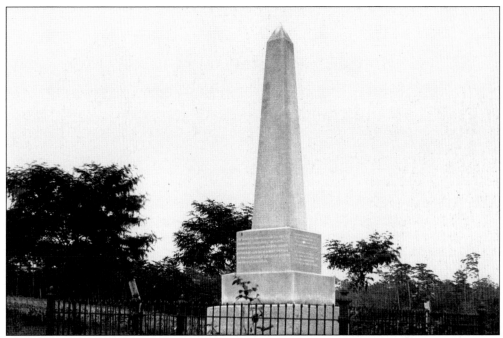

The Enoch Brown Massacre on July 26, 1764, was one of the most horrific terrorist events of Colonial times. Three American Indians approached the log schoolhouse where Brown was teaching nine boys and two girls and massacred all but one. Only Archie McCullough survived the scalping, though severely traumatized mentally and physically. This monument marks the site where the schoolhouse, the first one established in this area, once stood. (Courtesy of the Lilian S. Besore Memorial Library.)

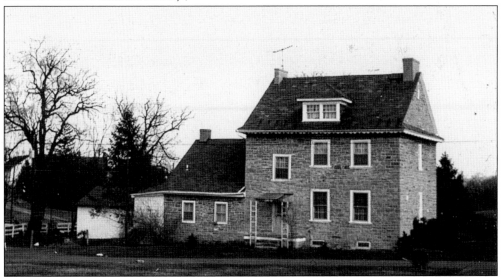

In 1765, Col. Thomas Johnston, the second son of James Sr., built his home at 11400 Stull Road on part of his father's estate. Twice during the Revolutionary War, Thomas served as a colonel. He was the adjutant in General Wayne's detachment at Paoli. The troops were greatly outnumbered during that battle on September 20, 1777, and many lost their lives that day. (Courtesy of the Allison-Antrim Museum.)

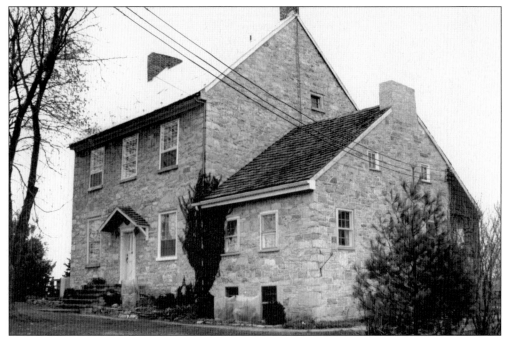

Dr. Robert Johnston, the fourth son of James Sr., married Eleanor Pawling and built this home at 12334 Williamsport Pike. From January 1775 to 1781, he served (in chronological order) as the surgeon to the 6th Battalion; the surgeon general for the Southern Department of the Army; and the personal physician (and friend) of George Washington. Dr. Johnston was present at Ticonderoga, Saratoga, Valley Forge, and the surrender of Cornwallis at Yorktown. (Courtesy of Frances Johnston Markle.)

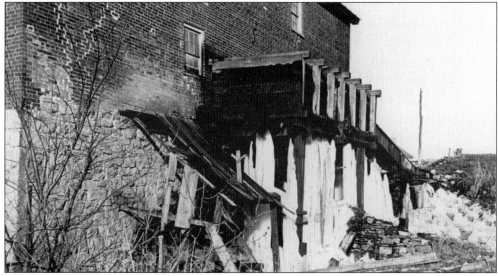

The Antrim Mill, of which few photographs exist, was located one-half mile west of town off Grant Shook Road. McCauley Spring's water was collected in two dams which, when released, provided the power to run the mill. The mill was still operating in 1910, according to bills of sale for flour and corn meal issued by L. E. Gonso, merchant miller at Antrim Mills. (Courtesy of the Lilian S. Besore Memorial Library.)

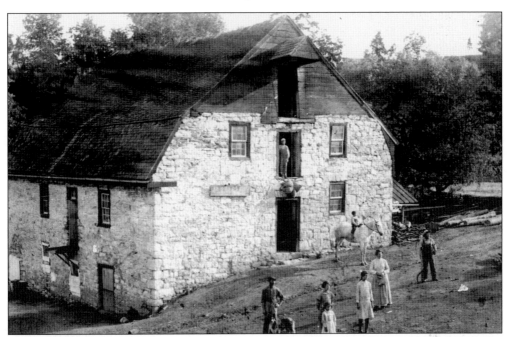

Gristmills were one of the earliest industries in Antrim Township. Farmers depended on the mills to grind wheat, corn, oats, and buckwheat into flour and meal for their families and livestock. Minnich's Mill, located near the Conococheague and Worleytown, was built by John Worley before 1796. On the property was one gristmill and two sawmills. (Courtesy of the Lilian S. Besore Memorial Library.)

In 1822, after his father purchased it, Jacob P. Stover and his wife moved to this property where only a log house and barn existed. Stover's sons Daniel and Emmanuel perfected the design of wind engines and established a company to produce them. Another brother, Mitchell, managed the Greencastle plant, which was the East Coast production site for the company, Stover Wind Engines. This property is now the Tayamentasachta Environmental Center. (Courtesy of the Allison-Antrim Museum.)

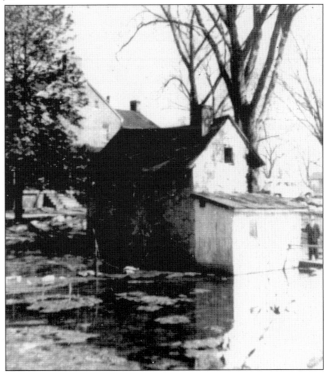

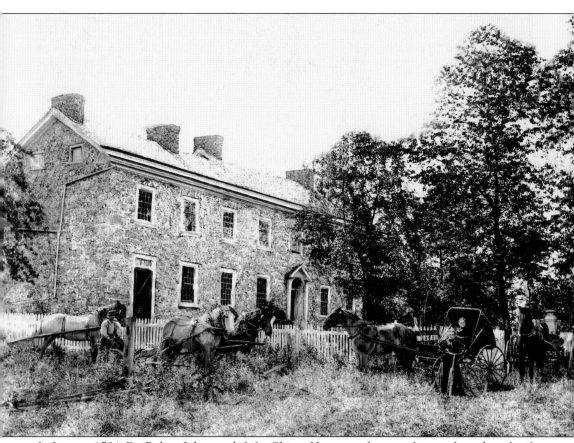

In January 1784, Dr. Robert Johnston left for China. He amassed a great fortune from the sale of U.S. ginseng, a product that he was personally allowed to take as cargo. Johnston was considered one of the wealthiest citizens of the area. In 1790, Dr. Johnston was appointed collector of excise for Franklin County. President Jefferson, a friend from the war, appointed Johnston the U. S. revenue collector for western Pennsylvania. During the early 1800s, the Johnstons started plans for a larger, more magnificent home to be built at 13082 Williamsport Pike. It was constructed of limestone with cherry and walnut interior decoration. The front door transom was designed like the Masonic "All-Seeing Eye." The wide entrance hall showcased a grand spiral staircase leading to the top floor. Unfortunately, Dr. Johnston died at the age of 58 on November 25, 1808, just a few months before the home's completion. His remains are buried in Cedar Hill Cemetery. His wife, Eleanor, moved into the house upon completion and lived there until her death 10 years later. (Courtesy of Edward and Betty Hessong.)

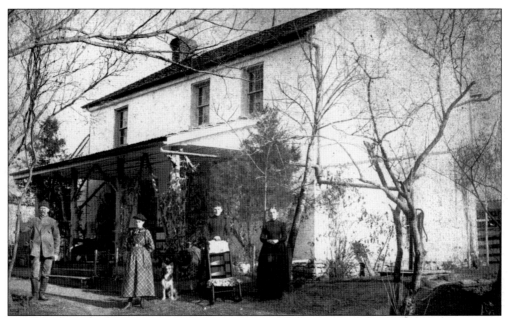

In 1846, Sidney Rigdon, an ex-communicated Mormon, brought a group of his followers to this farm at 2206 Buchanan Trail West, which was bought in 1844. The group was made up of farmers, mechanics, and professional men who worked on the farm and in town. The men failed at supporting themselves, and the farm was repossessed by McLanahan in 1847. The Riley Bitner family is shown in this photograph c. 1900. (Courtesy of Oliver Goetz.)

This home at 7949 Browns Mill Road was likely built in the first half of the 19th century, and the structure was added onto several times, giving it its unusual architectural details. The second addition of the Victorian tower, porch, and fancy brickwork caused the bankruptcy of the owner, Mr. Burkholder. Howard and Sallie Wishard's family stands at the fence. Noah Meyers purchased the property in 1937 for $2,500. (Courtesy of Nancy Pensinger.)

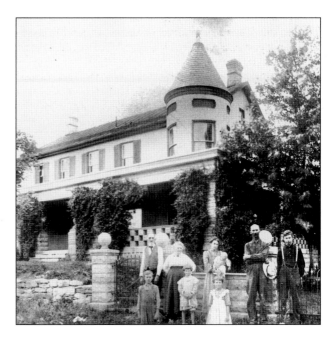

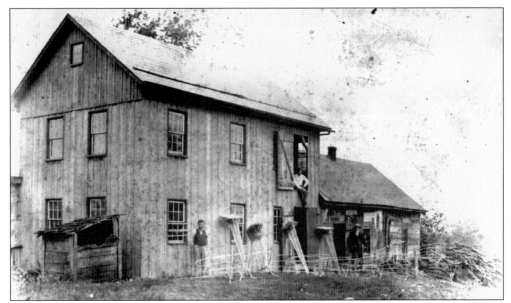

From 1863 to 1926, Henry Stickell Walck operated a factory where he made grain cradles (a scythe with attached "fingers"), which were used to cut ripe wheat. Wooden rakes and forks, as seen here against the building, were also made. The factory was located two miles east of town on the south side of Leitersburg Road at Canebrake. Everything handmade was housed in the oldest one-story section. (Courtesy of Virginia Walck Fitz.)

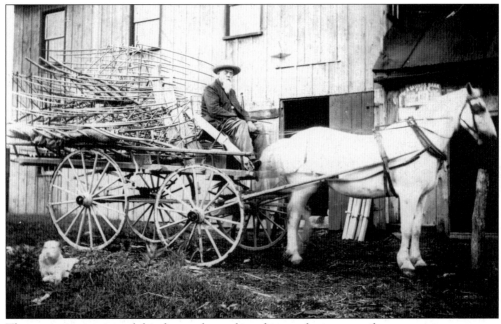

The two-story section of this factory housed machinery that was run by one stationary steam engine. The machines included a band saw, a circular saw, a regular lathe, a sanding machine, a boring machine, and a special lathe invented by Walck for making the cradle handles. Henry Walck appears with a wagonload of grain cradles ready for delivery. (Courtesy of Virginia Walck Fitz.)

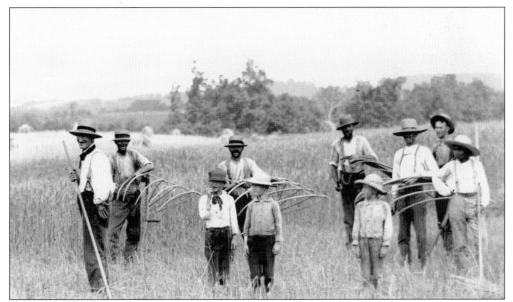

Men and boys work on the monumental task of cutting the wheat field. With four grain cradles, these men were able to cut about eight acres of wheat in one day. As the scythe cuts the stalks, they are cradled in the long fingers. The stalks are then raked together and gathered into stacks. Harvesting was well underway. (Courtesy of the Allison-Antrim Museum.)

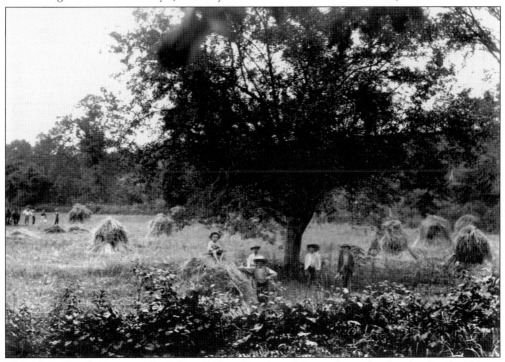

The wheat has been cut, raked, bundled, and gathered into wheat shocks. As the shocks are made, some of the stalks are laid crosswise on top to form a crown, allowing the rain to run off without soaking the stack too badly. These stacks will be put on the wagon, which is coming into the field, and taken to the barn for threshing. (Courtesy of Glen Cump.)

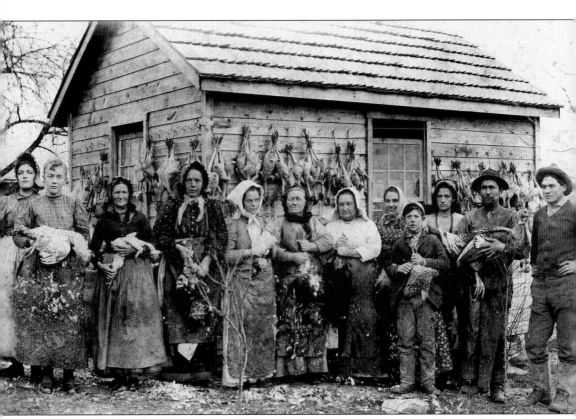

The story behind this photograph will have to be left to your imagination. Eleven of the twelve people seen are holding either dead or live fowl. There are chicken feathers everywhere; the chopping block is probably just out of camera's range. The solemnity of the faces is only cracked by one or maybe two of the people, who share a slight smile. Hanging on the walls of the small clapboard building behind them are 45 to 50 dead chickens. It is sometime between autumn and spring, as the trees are as naked as the dead chickens. What was this occasion? Could it have been a very large family gathering or a community event? The surnames of seven families are listed on the back of the photograph. Those pictured are, from left to right, Viola Sites, Em Wallech, Nancy Stout, Sarah Stickell, Frances Leiter, ? Horst, Linn Wallech, Molly Stout, Henry Morter, ? Stickell, Jacob Wallech, and L. H. Leiter. The photograph was likely taken in the 1890s. (Courtesy of Fred Schaff.)

The Peiffer family came to Antrim Township c. 1880 and purchased about 90 acres of land. Their top priority was to provide water and shelter for themselves. To meet the family's immediate needs, the log home to the right was built, along with a hand-dug well that is still in use. The second structure completed was the barn, built to shelter the animals that the family needed for survival. (Courtesy of Pam Anderson.)

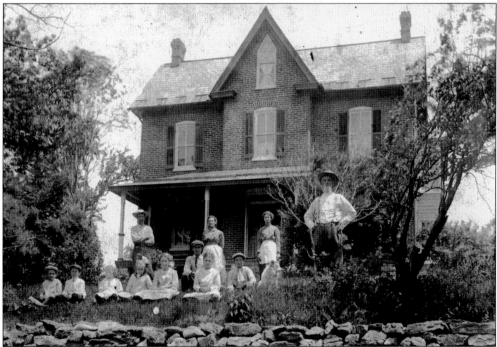

When the barn was finished, time was found to construct the much larger house above, located at 7778 Grindstone Hill Road. Many of the original architectural features, such as doors, door knobs and escutcheons, trim, and window panes, still remain. The Peiffer family posed just long enough to have a photograph taken for posterity. (Courtesy of Pam Anderson.)

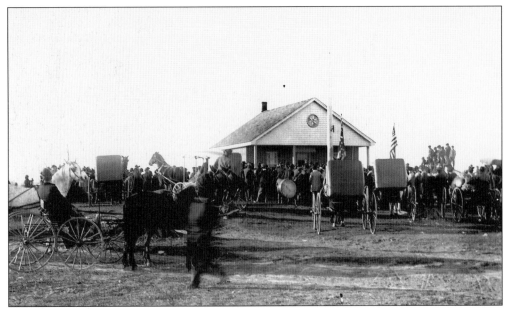

Prospect Hill School, a one-room Antrim Township school, was located where 704 East Baltimore Street is today. Built *c.* 1895, it closed in 1924, and the students then went to Brown's Mill for schooling. There was an important presentation on this day, as evidenced by the large gathering of people in this photograph made from a George F. Ziegler glass-plate negative. The Greencastle Brass Band provided music. (Courtesy of the Allison-Antrim Museum.)

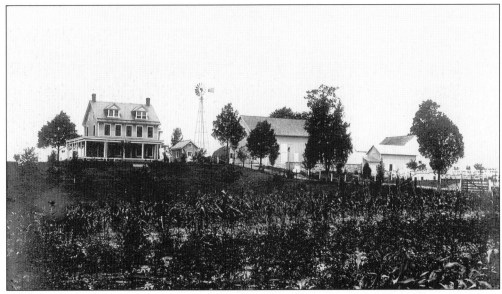

George F. Ziegler purchased this farm off Buchanan Trail West *c.* 1905 with funds received from the state. When the state took possession of the Waynesboro-Greencastle-Mercersburg Turnpike, a toll road, Ziegler was reimbursed as one of the stockholders. The Ziegler family spent summers here because of the cooler country temperatures. George took many photographs, using glass-plate negatives, at this country residence during the early 1900s. (Courtesy of Lloyd "Sonny" Rowe.)

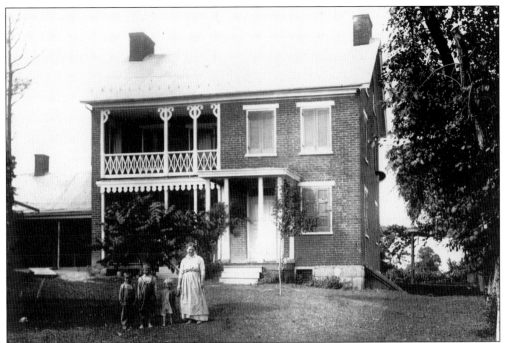

Aumeda Shank Gearhart stands in front of the first home she shared with her husband, Ira, whom she married in 1905. Likely built in the late 1800s, it is located at 13141 Gearhart Road and is typical of farmhouses of that time period. Ira, a farmer, ran for a seat on the Franklin County Commissioners' Board. The Gearharts' family of five children was raised here. (Courtesy of Ruby Zeger Oberholzer and Pat Zeger Martin.)

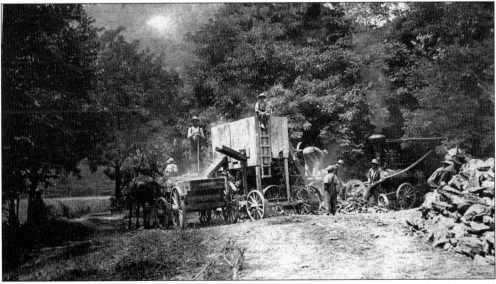

In addition to orchards, Howard Wishard dealt in the sale of steam engines, threshers, and stone crushers. This group of men is hard at work loading large stones, which were unearthed during the winter months, into the steam-powered stone crusher. A chute helps fill a wagon with crushed stone, which will then be sold to pay taxes. The crushed stone was used to pave roads. (Courtesy of Raymond Wishard.)

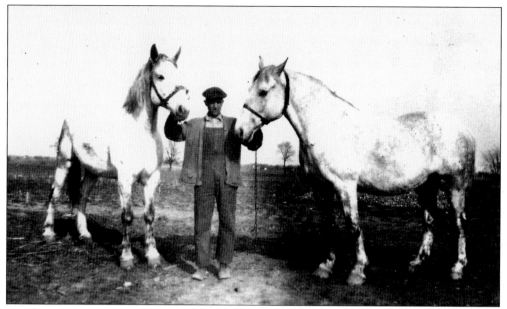

Good work horses were required for any farm in order to complete everyday tasks. The Athertons preferred the Percheron breed. Clarence stands between Kitty (left) and Pet (right). The Athertons also had black Percherons, which they showed for many years at both the Harrisburg Farm Show and the Hagerstown, Maryland, fair. Many blue and red ribbons were collected over the years from their prize horses. (Courtesy of Oliver Goetz.)

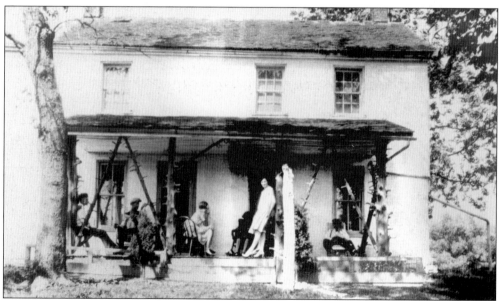

On a Sunday afternoon c. 1925, Oliver and Mary Cole Atherton and their children—Bertha, or "Sis," Lil, Thomas, Clarence, and Norman—relax on the front porch of their home, located about a mile west of town at 2206 Buchanan Trail West. The Athertons farmed this land for many years, just as previous owners had done ever since James Rody arrived in this area. (Courtesy of Oliver Goetz.)

Two
GREENCASTLE

Col. John Allison was born on December 23, 1738, in Antrim Township. He served in the Revolutionary War and seconded the motion to ratify the Constitution of the United States at the Pennsylvania Convention. Allison founded Greencastle in 1782. He died on June 14, 1795, and was buried in the Moss Spring Cemetery. This log house, formerly at 321 West Baltimore Street, was the home of Mary Ellen and William Moore and is representative of those built during Allison's time. (Courtesy of the Lilian S. Besore Memorial Library.)

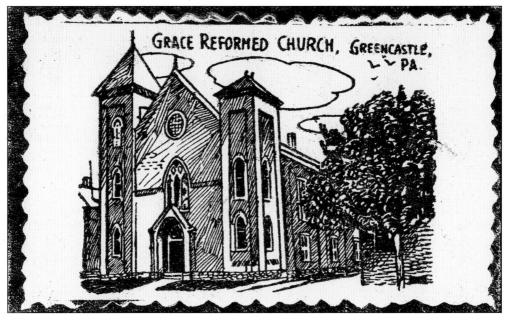

On May 9, 1748, Rev. Michael Schlatter preached to a German Reformed congregation on a farm. In 1787, the first log church structure was built on South Carlisle Street. It was shared with the German Lutheran congregation until 1808, when a brick building was erected at that site. The Grace United Church of Christ sanctuary, as seen on this leather postcard, was dedicated on June 3, 1855. (Courtesy of Denise Bricker.)

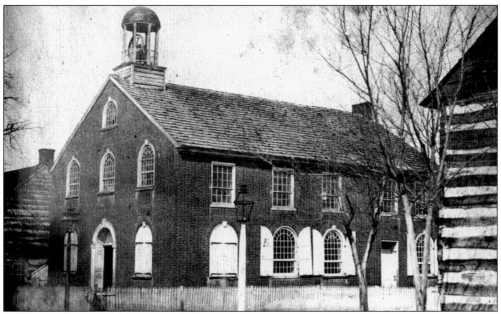

The German Lutheran congregation was organized c. 1775. For a period of 12 years, the Lutherans shared the German Reformed log church on South Carlisle Street for services before constructing in c. 1810 their first church building (seen here). It was built during the pastorate of Rev. John Ruthrauff, who served for 40 years. The construction of the present Evangelical Lutheran Church structure began in March 1875. (Courtesy of the Lilian S. Besore Memorial Library.)

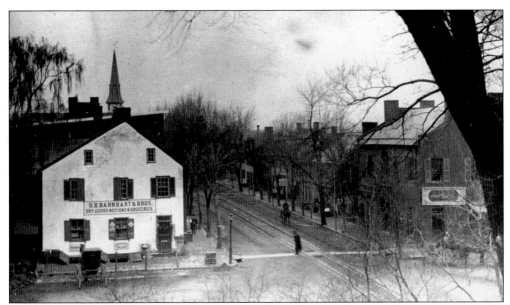

On October 13, 1794, President Washington, along with his staff and Horse Guards, stopped at the McCullough House tavern on the southeast corner of the square for a respite before traveling a couple more miles down the Williamsport Pike to visit his friend Dr. Robert Johnston. Washington was on his way from Carlisle to Williamsport, Maryland, to meet the Maryland troops that later helped quell the Whiskey Rebellion. (Courtesy of Evelyn Pensinger.)

The Brethren congregation was established in 1805, when Bishop Christian Newcomer preached his first sermon in Greencastle. The first Brethren church on this site was a frame structure costing $900 in 1829. The Brethren denomination merged with the Methodists in the 1960s. The current brick building of the First United Methodist Church was built in 1884, and renovations have taken place since then. (Courtesy of the Lilian S. Besore Memorial Library.)

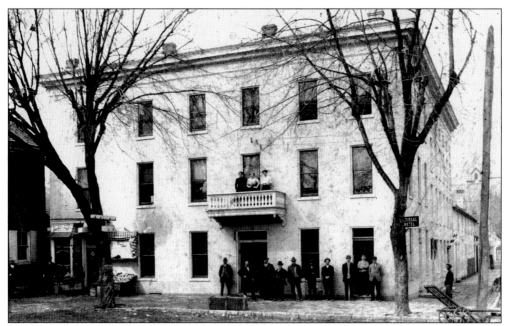

In 1763, on this site owned by William Allison Sr., a tavern stood at the crossroads of the Kings Highway and a dirt road to Baltimore. This crossroads area became Greencastle's square in 1782. In 1859, John Brown stayed here at the Union Hotel on several occasions, planning his raid on Harpers Ferry. After renovations *c.* 1905, the establishment became known as the National Hotel and closed in 1920 during Prohibition. (Courtesy of the Allison-Antrim Museum.)

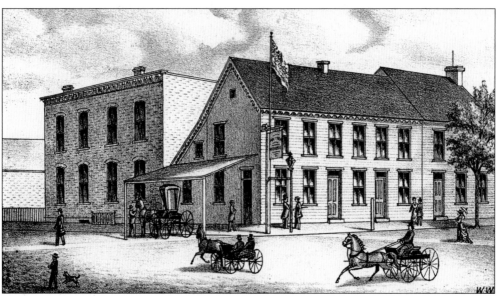

J. Thomas Pawling opened a hostelry at 104 East Baltimore Street in 1859 and called it the Antrim House, after County Antrim, Northern Ireland, from whence he had immigrated. The building was of clapboard construction. The Antrim House was exceedingly busy during the reconstruction of the Franklin Railroad when a great number of new people were hired to help build the line. (Courtesy of Don Hummer.)

The Winger Building, which was Lt. Col. Benjamin F. Winger's residence in town, was on the southwest corner of the square and South Carlisle Street. The main entrance opened on the Carlisle Street side and boasted a little portico. Winger's *Greencastle Press* office was on the west end of the first floor. This site was Lot No. 2 on Allison's plat and was where John McLanahan built the first business establishment in 1812. (Courtesy of the Allison-Antrim Museum.)

William J. Patton built this house at 23 West Baltimore Street in 1865. He became the sole owner of the *Echo Pilot* in 1908 and then sold it to G. Fred Ziegler in 1925. The paper was printed in the building, now used as a garage, that appears in the background. The family may be celebrating one of the early Old Home Weeks. (Courtesy of the Allison-Antrim Museum.)

Prospect Hill was owned by John Ruthrauff *c.* 1855. This 1940 photograph shows the stately home, with its English boxwoods, at 327 East Baltimore Street. The 75-acre property included orchards (now Orchard Circle) immediately south of the home and a barn. A packing house was a short distance southwest. Addison Imbrie purchased Prospect Hill in 1875. It was later sold to the Rahauser family. (Courtesy of Richard H. Gingrich.)

In 1860, out of dissatisfaction for the official manse, Rev. Edwin Emerson, the Presbyterian pastor, built his own manse at 165 South Washington Street. The lumber came from Greencastle's first steam-powered sawmill, a business venture between Emerson, Gen. David Detrich, and W. H. Davison. The cottage had a circular driveway and was surrounded by English boxwoods. Tradition holds that during the Civil War era, escaped slaves were hidden in a secret attic room. (Courtesy of Tom and Alice Brumbaugh.)

In 1860, Jacob Hostetter opened a grocery at the corner of Center Square and West Baltimore Street. He sold the freshest groceries and staples brought from Baltimore and other cities on his own railroad car. In later years, Hostetter's was known for its fine china and pottery, which was shipped across the nation. A third story was added to the building in 1908. (Courtesy of the Allison-Antrim Museum.)

In 1868, the four one-room schoolhouses that serviced the children of the borough closed when the new public school building opened. The school was built at the corner of South Washington and East Franklin Streets. It accommodated all the grades at that time. If parents paid their tuition, Antrim Township students could attend the high school for college preparatory classes. (Courtesy of Lloyd "Sonny" Rowe.)

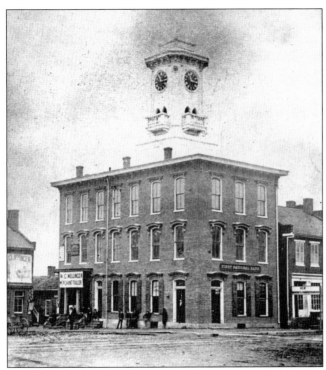

In 1870, the First National Bank, the oldest private bank in Franklin County, moved to this location from two buildings north on Carlisle Street, where it had opened for business in 1865 in William C. Kreps's residence. The town clock was not completed until 1872. Greencastle's town clock is the most recognizable landmark in town, and the square is one of the most beautiful in the area. (Courtesy of the Allison-Antrim Museum.)

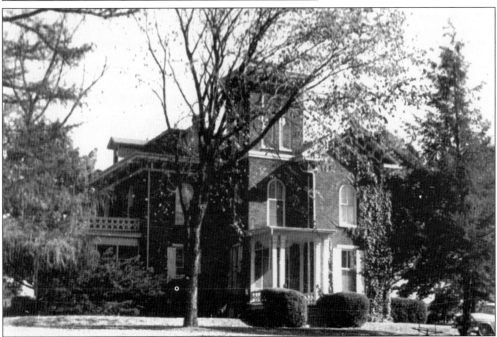

Rosemont was built by Judge D. Watson Rowe in 1872. It faced South Allison Street, with Rowe and Addison Avenues on the north and south. The half-block-square estate was surrounded by a six-foot-high, honeysuckle-covered wire fence. Huge iron gates opened to a circular driveway with a golfing green in the center. Rosemont was also the Greencastle residence of Henry P. Fletcher, the nephew of Judge Rowe. (Courtesy of Isabelle Barnes.)

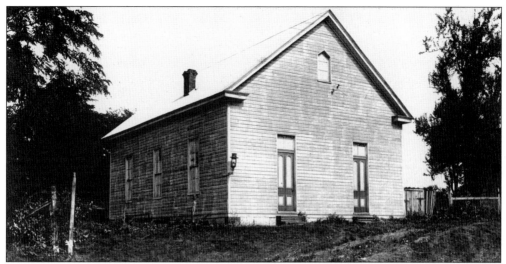

The land for the Bethel American Methodist Episcopal Church at 227 South Carlisle Street was bought in trust by Moses Anderson, Matthew Anderson's father, in October 1867 from Daniel and Mary Snively of New Albany, Illinois. The frame building was not built until eight years later. (Courtesy of the Lilian S. Besore Memorial Library.)

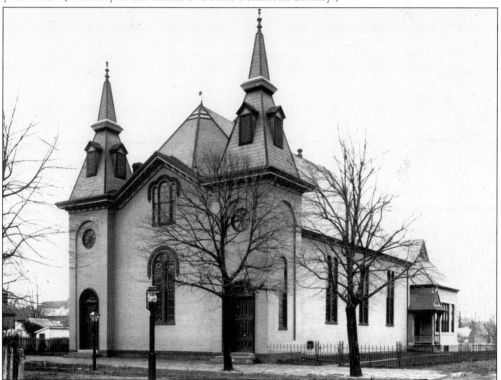

This c. 1885 photograph of the Greencastle Presbyterian Church at 57 West Baltimore Street was found among the glass-plate negatives of George F. Ziegler, a member of the church and an avid photographer. Never before seen publicly, it was taken during a time period from which specific records are not available, though the church is still mentioned in general terms in various historical accounts. (Courtesy of the Allison-Antrim Museum.)

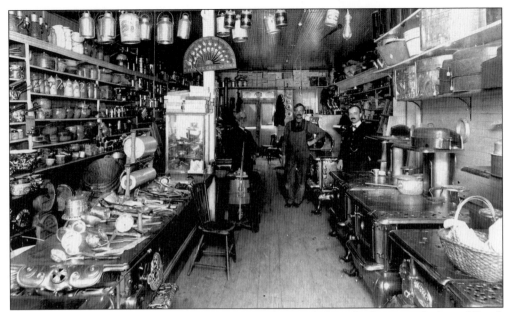

J. Lesher & Son, at 39 East Baltimore Street, advertised that the business dealt in "Quick Meal," wickless blue-flame gasoline engines, refrigerators, and more. This heating, tinning, spouting, and stove business started *c.* 1885 and also sold furnishing wares. By the time the business was sold to James H. Craig Sr. in 1922, indoor plumbing was commonplace in homes and gasoline was being sold for cars. (Courtesy of the Allison-Antrim Museum.)

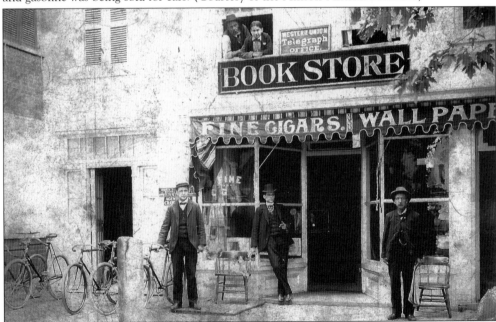

Carl's Book Store, owned by Pitt Fessenden Carl, was located at 8 Center Square for 48 years. Pitt, an expert telegrapher, also managed the local Western Union office here for 30 years. The bookstore was the gathering place to learn the latest news and discuss local and national topics of interest. Crowds gathered on election nights to hear the first results come in by telegraph. (Courtesy of Lloyd "Sonny" Rowe.)

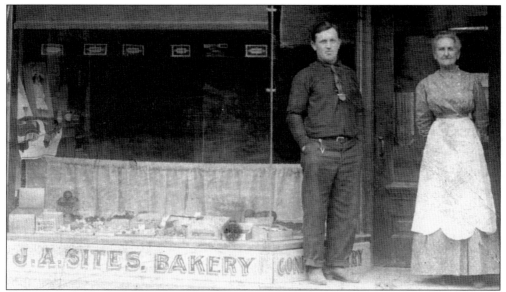

Jacob and Anna Sites operated a bakery and confectionery at 7 South Carlisle Street. In this *c.* 1900 photograph, Luther Sites and his mother, Anna, are seen at the entrance to the shop, which also sold candy, ice cream, and ice-cream sodas. Jacob and Anna's daughter Belle Sites Meyers operated Belle's Dry Goods on the opposite side of the street at 18 South Carlisle in the 1930s. (Courtesy of Ruth Eckstine.)

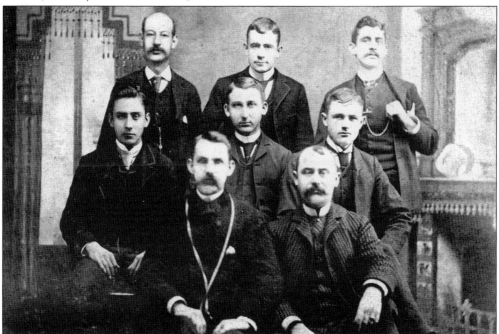

Thomas W. Brendle and Will Bert were partners for a time before Brendle established his own men's clothing house. The business was located in the west end of the bank building adjacent to Clippinger & Spielman. The tailors were, from left to right, as follows: (front row) Brendle and Bert; (middle row) Paxton Kuhn, Ed White, and Whitey Alleman; (back row) John Heck, Grant Miller, and Sprague McCrory. (Courtesy of Tom and Alice Brumbaugh.)

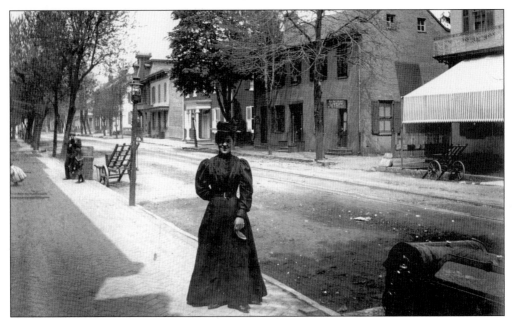

The train station (the fourth building from the right) was purchased from the Cumberland Valley Railroad by the Citizens Bank. The bank opened for business on July 1, 1901, with the idea that it should meet the financial needs of and provide investment opportunities for the everyday citizen. Esther Angle pauses for a photograph *c.* 1895 across from the Crowell House. Nearby is a peanut roaster. (Courtesy of the Lilian S. Besore Memorial Library.)

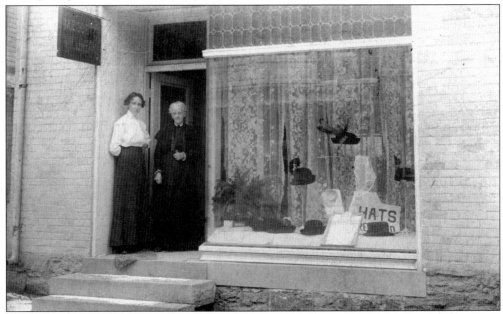

Margaret Goetz and her mother, "Ma" Goetz, stand at the entrance of Margaret's M. E. Millinery Shop at 107 East Baltimore Street *c.* 1900. Margaret's niece, Isabel Reymer, worked with her in the business. The merchandise arrived from Baltimore, Philadelphia, and New York City, bringing ladies in from miles around to purchase the hats. Margaret closed her shop in the late 1950s. (Courtesy of Jean Oliver Reymer and Robert C. Reymer Jr.)

J. S. Eshelman's Grocery dealt in country produce and "fancy and staple" groceries. The shop's enclosed delivery wagon gave the business address as "opposite Franklin House." The three-story grocery building was later removed to accommodate a parking lot for the First National Bank. (Courtesy of the Allison-Antrim Museum.)

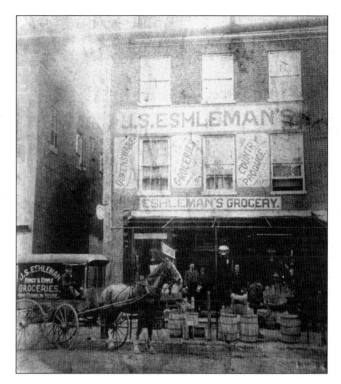

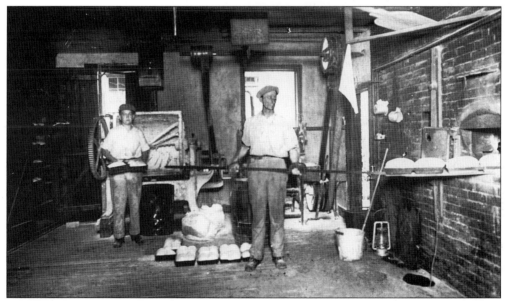

During the early 1900s, Tom Clary owned the building at 15 Center Square, which was both his place of residence and his business. The confectionery was in the front. His bakery, seen here, was in the back, along with an ice cream parlor. Clary delivered ice cream and bread to customers around town. Warren Besecker is on the left, and Lank Williams is on the right. (Courtesy of Joe Henson.)

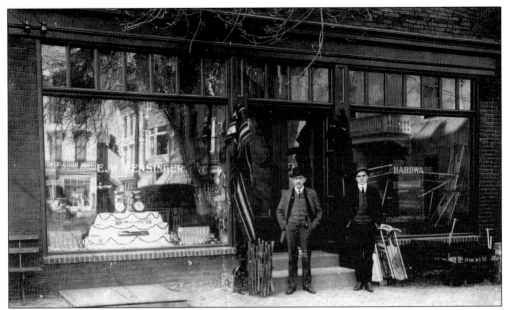

Edgar W. Pensinger (left) stands in front of his hardware store at 27 Center Square. He first worked in his uncle Jacob's hardware store. Upon his uncle's retirement on January 1, 1908, he became sole owner of the 55-year-old establishment. Edgar moved the business to this location several years later. This photograph was taken in the winter, as evidenced by the sleds. (Courtesy of Jon Pensinger.)

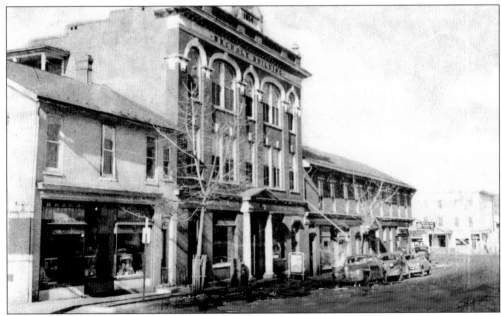

T. W. Brendle, owner of the men's Clothing House on the southeast corner of the square at Baltimore Street, built the three-story Brendle Building in 1914. Croft's Drugstore was located at 21 East Baltimore Street, and Witmer's Grocery was at 9 East Baltimore Street. The Brendle Building, situated in between at 11 East Baltimore Street, became the new home of the Greencastle post office. (Courtesy of the Allison-Antrim Museum.)

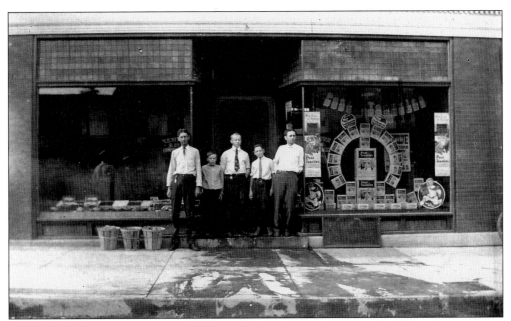

W. H. Witmer & Brothers grocery, 9 East Baltimore Street, was located to the right of the new Brendle Building. One of the windows is totally devoted to a Post Toasties display. With such a large advertising display, was this a new, processed, and ready-to-eat breakfast cereal? The Witmer brothers also had a grocery store at 27 Center Square. (Courtesy of Lloyd "Sonny" Rowe.)

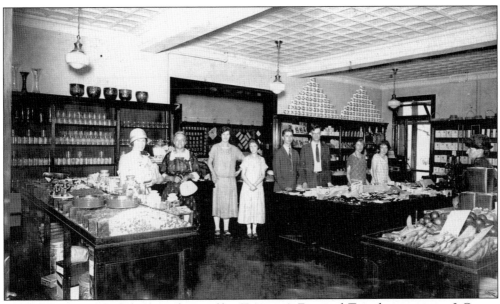

Jacob Trimmer of Carlisle opened one of his Trimmer's Five-and-Ten chain stores at 3 Center Square c. 1920. It was a general store that had "everything under the sun," from candy, hankies, and small gifts to hardware items. Branton and Carrie Holstein bought the store in 1940. Seen in the photograph, from left to right, are two unidentified customers, Mabel Haggerman, Myrtle Shipp, Aaron Zuck, Mr. Weakly, Mildred Lear Toms, and Thelma Ryder. (Courtesy of Mary K. Myers.)

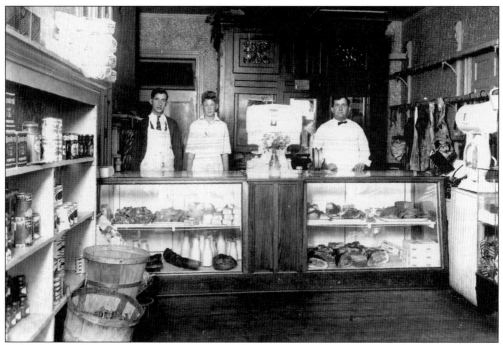

Robert Goetz (left) worked for his brother John (right) in the Goetz Meat Market at 5 South Carlisle Street *c.* 1925. John's son Kenneth (middle) worked in the store and made deliveries. Ice from the Ice and Cold Storage was used to keep the meat cold in the truck while deliveries were made to customers' homes around town and in the township. (Courtesy of Saundra Starliper.)

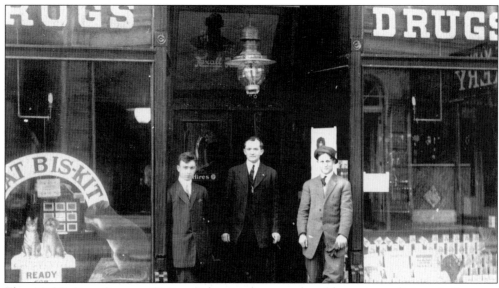

The ARCO Drug Store at 55 East Baltimore Street only sold patent medicines. J. Bowman "Doc" Metz, the pharmacist who appears in the center, did not prepare any medications sold to his customers. ARCO stood for American Remedy Company. The ARCO Music Room was located at the back of the building and sold Victrola-brand phonographs as well as sheet music. (Courtesy of Anna E. Sheely.)

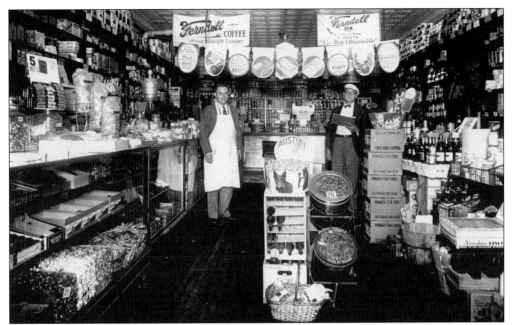

David W. Shinham, seen here on the left, opened a general store at 217 East Baltimore Street in March 1921. It was a family business primarily run by the Shinhams, who lived on the second floor. Due to David's illness, the store closed in August 1968. David Shinham passed away in September 1968. Mr. Caple, on the right, was a salesman for J. W. Myers & Company, a wholesale distributor. (Courtesy of Evelyn Shinham Shatzer.)

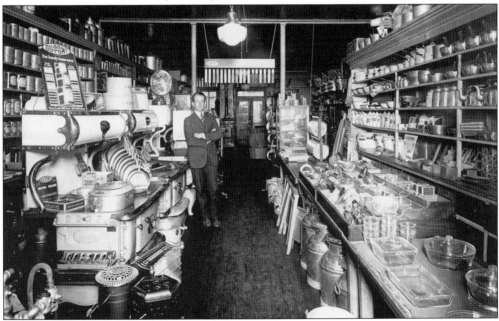

James H. Craig Sr. bought the business of J. Lesher & Son at 39 East Baltimore Street in 1922. He dealt in plumbing, heating, roof tinning, spouting, and stoves. In the front part of the store, home heating stoves that burned coal and wood were sold. When Craig retired in 1972, he sold his business to Mec Miller. (Courtesy of James H. Craig Jr.)

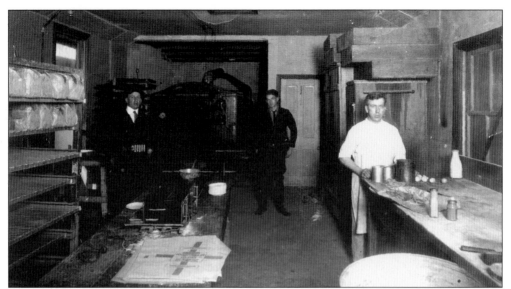

The Henson and Stellar Bakery was located at 35 Center Square between March 1922 and January 1930. James Stellar withdrew from the firm in 1930, at which time Henson continued on his own, eventually moving the business to his North Carlisle Street residence. Shown inside their "modern" baking room are, from left to right, Jim Stellar, Max Glass, and Earl Henson. The Henson Bakery was in operation for more than 50 years. (Courtesy of Oliver Goetz.)

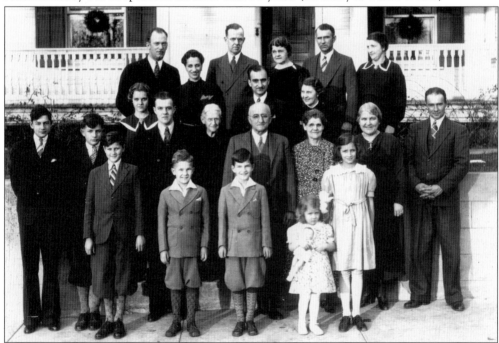

On Christmas Day 1936, the Gingrich family gathered at 318 East Baltimore Street. The family patriarch, Samuel H. Gingrich, stands in the center of the second row to the left of his wife, Nettie Diehl Gingrich, and to the right of his mother-in-law, Leah Kuhn Diehl. Leah and her husband, George, built this house at the turn of the century. The property left the Gingrich family when it was sold in 2002. (Courtesy of Richard H. Gingrich.)

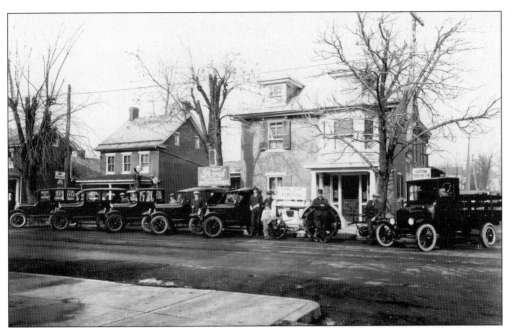

Eldon Hochlander, seen here on the left, was one of the very early Ford franchise owners. Having just arrived, the 1926 models, including a Fordson tractor, were displayed for all to see. The car window reads, "Here is what you are looking for, 1926 Models." These cars sold for $602 and $558. The house on the right in the photograph at the corner of Allison and Baltimore Streets was replaced with Hochlander's showroom and garage. (Courtesy of P. Sean Guy.)

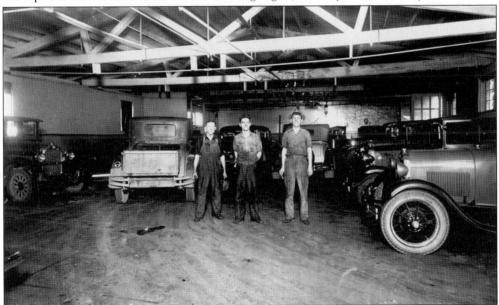

Inside the Ford repair shop c. 1930 are, from left to right, George Kuhn, Robert C. Reymer Sr., and Irvin Myers. Kuhn and Reymer were two of the early mechanics. They learned by doing but also by attending service center trainings. When the early Fords arrived by rail on South Carlisle Street, they were not completely assembled. It was the mechanic's job to finish assembling the fenders and hoods. (Courtesy of Andy Reymer.)

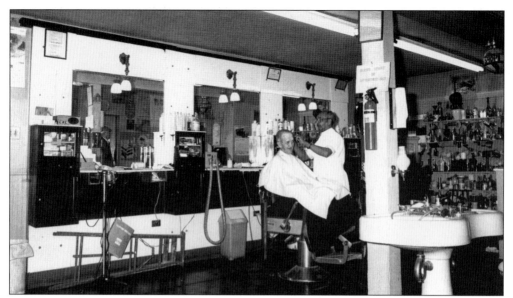

The Roscoe and Dixon Barber Shop, located at 17 Center Square, was owned by Lance "Lover" Roscoe and Jack Dixon. The business operated from the late 1930s into the 1950s until Dixon's death. Lover continued the business himself and is seen here giving Nelson Myers "just a little trim" before he goes on his way. The barber shop had a steady clientele of loyal customers. (Courtesy of the Lilian S. Besore Memorial Library.)

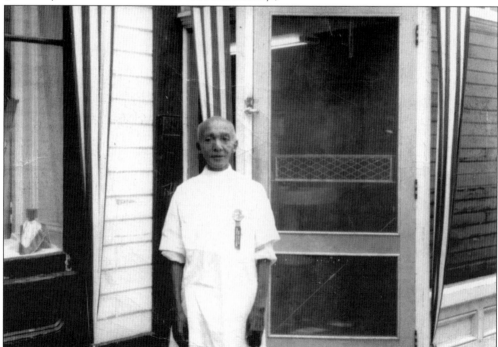

Jack Dixon, business partner of Lover Roscoe, stands outside the door to the barber shop at 17 Center Square. This photograph was taken during an Old Home Week, as evidenced by the badge that he wears. What better place for the "Old Boys" to catch up on reminiscing than in one of the barber shops? (Courtesy of Jackie Dixon.)

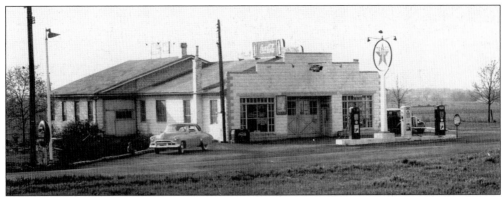

In 1945, Alvin Hicks opened a body shop in the rear of the Mason Dixon Truck Terminal. Potter's Restaurant occupied the left front of the building. Hicks added appliances to his business in 1947 and then bought the Chevrolet dealership on February 28, 1950. On January 27, 1963, a fire destroyed the building. Within nine months, Hicks had built a new showroom and a garage at the same location. (Courtesy of Kermit Hicks.)

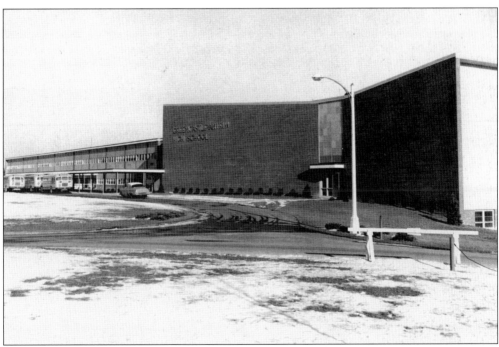

In July 1954, the school districts of Greencastle and Antrim Township merged, bringing special services for the students such as lunch programs, special education, and expanded library services. Shady Grove and South Antrim Elementary Schools opened in September 1955. Because of the merger, a larger facility was required at the secondary level. The Greencastle-Antrim Junior-Senior High School building on South Ridge Avenue opened in September 1960. (Courtesy of World Kitchen.)

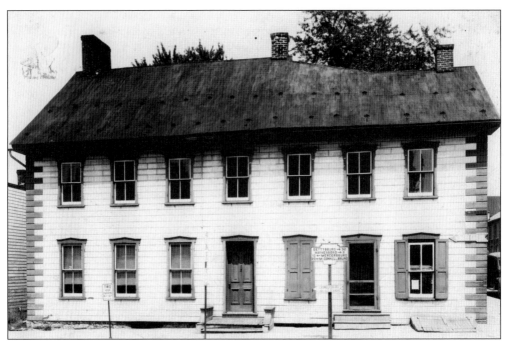

The current post office at 2 North Washington Street was dedicated on Saturday, April 23, 1960. This original two-story log structure, which had been owned by the Heck family since the 1800s, was removed c. 1940 to make room for the post office. Construction was put on hold because of World War II and was not completed until 1960. George Heck's residence was on the left and John Crunkleton's Meat Market was on the right until c. 1940. (Courtesy of Carla Wright.)

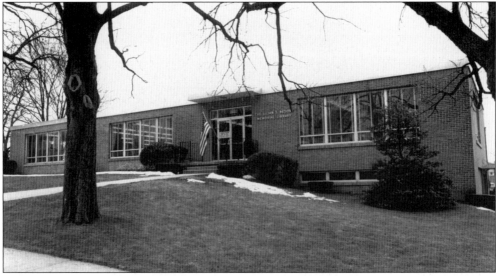

Greencastle's first library was located at 46 North Carlisle Street. Calvin Besore gave a monetary donation in memory of his mother and teacher, Lilian S. Besore. Controversy surrounded the choosing of the site because many of the townspeople thought the location was too far out of town. Regardless, the Besore Library opened in October 1962. (Courtesy of the Lilian S. Besore Memorial Library.)

Three
VILLAGES

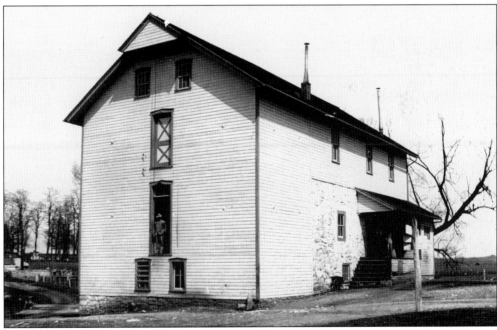

Brown's Mill was built in 1772 by George Brown. The stone gristmill got its power by harnessing the flow of water from two branches of Muddy Run. It supplied the local needs of the area until it was destroyed by fire in August 1929. It was never rebuilt because electricity was beginning to take over as the power source for all milling industries. (Courtesy of Isabelle Barnes.)

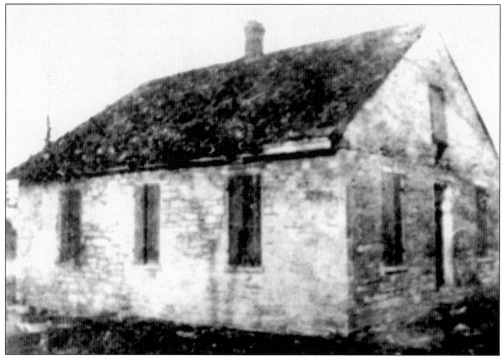

The earliest school in the village of Brown's Mill was a 1789 log structure built to accommodate the educational needs of the children at that time. This 1836 limestone, one-room schoolhouse, known as the Brown's Mill School, replaced an 1804 school that had become too small. Forty-one teachers, none with a college degree, taught here until its closure in 1921. (Courtesy of Glen Cump.)

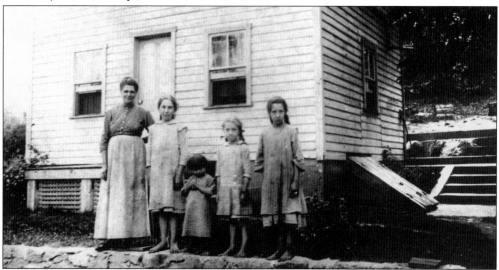

Charles Albert Bentz married Sallie Ann Stoner in 1892 and moved to the Brown's Mill area, where he built a home for them at 7330 Talhelm Road. Charles worked in orchards and farming. Sallie is shown in this c. 1915 photograph with four of her children. They are, from left to right, Margie Catherine, Esther Gail, Caroline, and Mabel Irene. Margie was the grandmother of Patricia Muck. (Courtesy of Patricia Muck.)

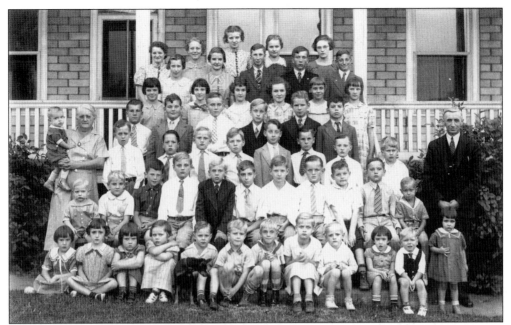

The Milton Wright Memorial Home was opened in 1921 by Rev. Clarence A. and Ada Hoover under the supervision and ownership of the Otterbein United Brethren Church. During their nearly 50 years of operating the home for wayward and orphaned children, the Hoovers loved, cared for, and raised more than 366 children. Those in this photograph were living at the Milton Wright Home in 1938. (Courtesy of Frank Kesselring.)

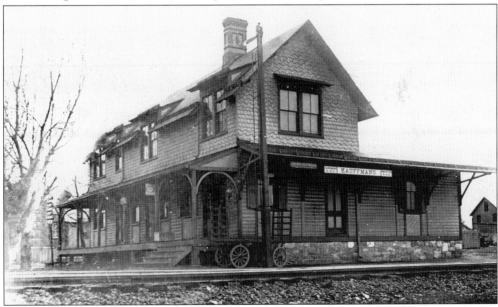

In 1889, the Cumberland Valley Railroad built the above station and changed the name of the community from Brown's Mill to Kauffman's Station. In addition to the freight train station, the building housed the post office and a grocery store. Also occupying the building was Adams' Express. In addition, there were signs informing the traveler that Harrisburg is 60 miles and Winchester is 56 miles away. (Courtesy of Isabelle Barnes.)

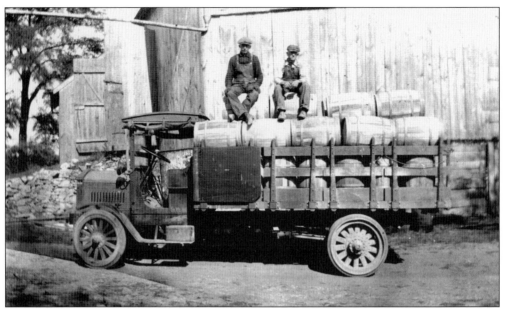

The Wishard family property included 700 acres between Kauffman's Station and Clay Hill. The packing house had just opened at the Howard Wishard orchards in this 1923 photograph. Employee Mart Fox (left) and Ernest Wishard sit atop 76 barrels of just-packed apples ready to be driven to the Kauffman railroad station for shipment. Before the packing house opened, the apples were packed in the fields. (Courtesy of Raymond Wishard.)

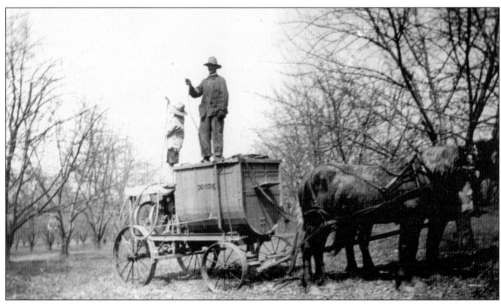

Dave Wetzel and his son John spray pesticide on the apple trees in Wishard's orchards in March. In the interest of family survival, parents relied on their children to help with the work. The gasoline engine sprayer is being transported by good old-fashioned horse power. (Courtesy of Raymond Wishard.)

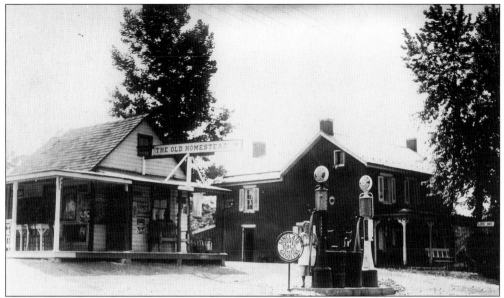

Each little hamlet or village had its own small general store. In Bushtown, located just south of the Interstate 81 exchange and Route 11, the Old Homestead was owned and operated by Rube and Blanche Snodderly. Blanche is seen here behind the Sinclair gas pump. It is believed that General Lee's troops camped in this area (Lee's Woods) on their way to Gettysburg. (Courtesy of Lloyd "Sonny" Rowe.)

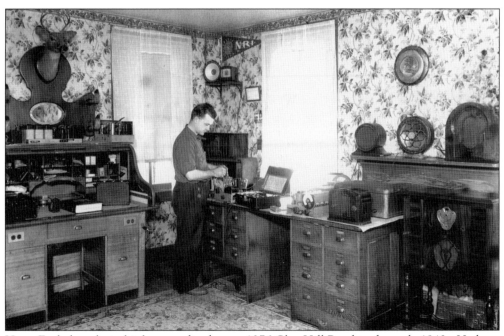

Harry Faubel works in his home radio shop at 1376 Clay Hill Road in the early 1940s. He later moved his shop to 42 South Main Street, Chambersburg, where he became the first in Franklin County to install car radios for his customers. A pennant on the wall indicates that he trained at the National Radio Institute. (Courtesy of Mary Ellen Faubel.)

The Clay Hill Union Church was built in 1878. Its purpose was to serve all the people of the community. When it opened, trustees were named from seven different denominations: Brethren, United Brethren, Brethren in Christ, Lutheran, Mennonite, Presbyterian, and Reformed. It has remained a union church ever since its inception and is still serving the members of the community today. (Courtesy of Mary Ellen Faubel.)

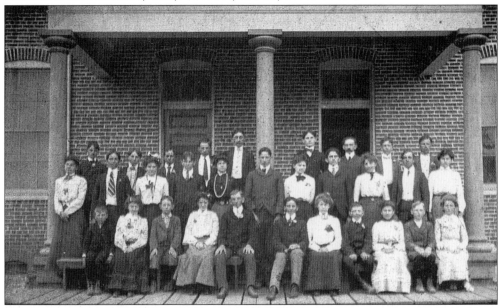

At the time it was established in 1838, the Clay Hill School was a one-room, brick building. Jacob S. Smith (seventh from the left, back row) was born in Antrim Township and taught at Clay Hill for eight years between 1884 and 1894. As county superintendent, he was instrumental—not only at the county level but also at the local level—in achieving educational advancements for this area. (Courtesy of Mary Ellen Faubel.)

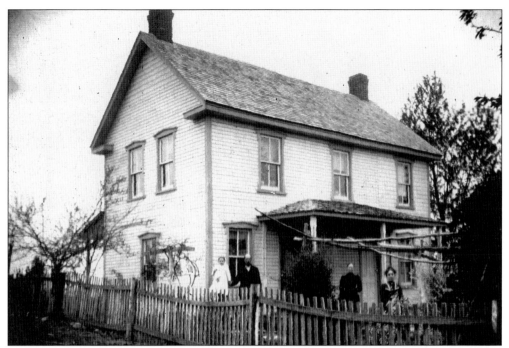

In 1889, the year of the Johnstown flood, John Jacob and Eliza Kesecker Brindle moved into this house at 3958 Coseytown Road. They raised their daughter Leah Ema here. Shown in the photograph, from left to right, are Julia Hicks, John, Eliza, and Leah Ema Brindle Hicks. (Courtesy of Ferne Tritle.)

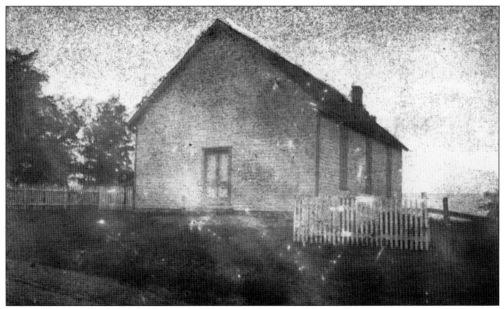

The Pleasant Hill United Brethren in Christ Church at 3664 Coseytown Road was built in 1899. Before the building was constructed, the congregation held services in the nearby White Pine one-room schoolhouse. The building still looks very much as it did more than 100 years ago, and services are still held there every Sunday. (Courtesy of Ferne Tritle.)

In this *c.* 1915 photograph, Albertus Ambrose Hicks (right) stands outside the entrance to his country store in Coseytown, which opened in 1908. He sold flour, sugar, barrel molasses, candy, and Gulf gas. Hicks closed the store in 1937. He was also a painter and a paperhanger. Hicks's home at 3890 Coseytown Road, which he moved into in 1898, is to the left of the store. He and his wife, Leah Ema Brindle, had five children: Julia, Rhoda, Velda, Alvin, Glenn, and Ferne. (Courtesy of Kermit Hicks.)

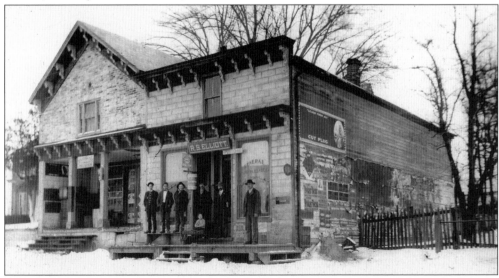

The grocery store in Shady Grove was originally built in 1848 by Melchi Snively, the founder of Shady Grove and the village's first postmaster. Rueben Elliott, owner at the time of this photograph, was the next proprietor of the general store, and the post office was still located there. Wilbur Brown, Dan Grove, Harry A. Grove, Ray Kline, and Barry and Terry Kline were succeeding owners. (Courtesy of the Shady Grove Community Center.)

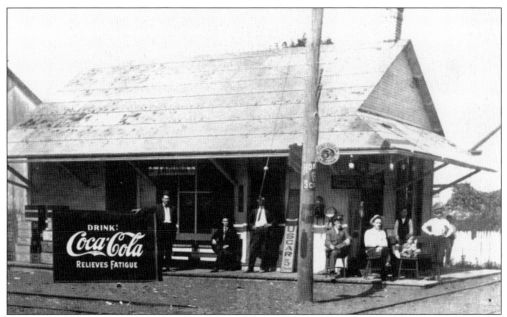

John "Pap" Wingert ran a general store at 1814 Buchanan Trail East (now the post office) in Shady Grove. He carried mostly grocery items such as flour, sugar, and molasses out of a barrel but no produce. Although Wingert's Store was small, it had the only soda fountain in Shady Grove where one could get fountain Cokes. During the Depression, he often cut pints of ice cream in half and sold them for 8¢ each. (Courtesy of Carla Wright.)

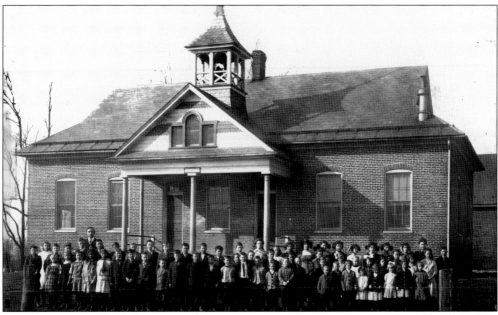

The Shady Grove School was one of three two-room schoolhouses in Antrim Township. The other two were located in Clay Hill and Middleburg (State Line). The last session of school in this building ended in the spring of 1955. The oldest alumni of this school are now in their 90s and still attend an annual reunion on the first Sunday of November. (Courtesy of the Shady Grove Community Center.)

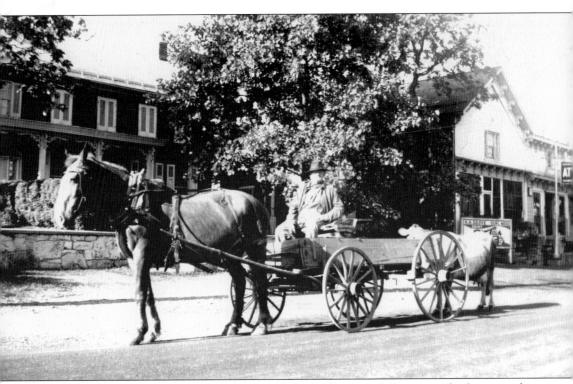

Ed Shoup grew up on a farm just southeast of Shady Grove and then owned a home at the corner of Gearhart Road and Route 16. He had a couple of cows and a truck patch and plowed gardens in the spring for neighbors. Shoup owned two fields in which he pastured his cows during the day. Each morning he took the cows, tying them to the back of the wagon, to one of the pastures and then brought them back in the evening for milking. In the background, the H. A. Grove Grocery can be seen. This photograph was taken in 1942 by Ethel Diehl, who lived in Shady Grove. Her nephew Bill Diehl, also from Shady Grove, was a serviceman stationed in Europe and a prisoner of war during World War II. Very homesick, he wrote a letter asking Ethel to take some photographs that would remind him of home. This is one of them. (Courtesy of Gladys Shoup Dentler.)

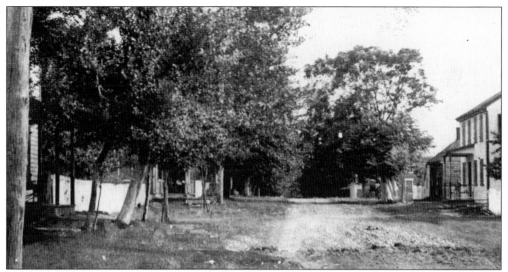

Spiglersburg, or Middleburg, was laid out in 1812. The borough limits went north from the Mason-Dixon Line and east and west of Route 11. In 1830, the government established the first post office here and changed the name to State Line. Its nickname was Muttontown because of the free-roaming sheep in the village. This view looks south from North Main Street. (Courtesy of the Middleburg–Mason-Dixon Historical Society.)

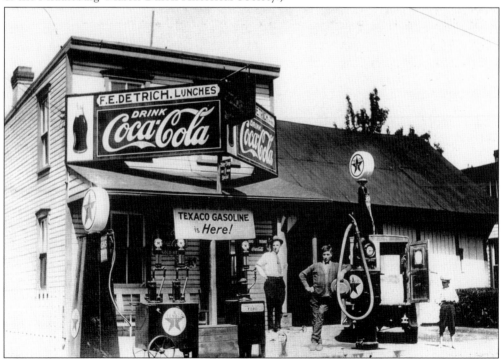

Frank E. Dietrich (left) ran this lunch and Texaco gasoline establishment when this photograph was taken in 1926. Gas was 11¢ a gallon. Clyde Kitzmiller (center) became owner of the store in the mid-1940s. The general store was where one could buy hardware, sewing notions, bolted materials, shoes, and fresh meats. Behind the right gas pump is a delivery wagon for the store. (Courtesy of the Middleburg–Mason-Dixon Historical Society.)

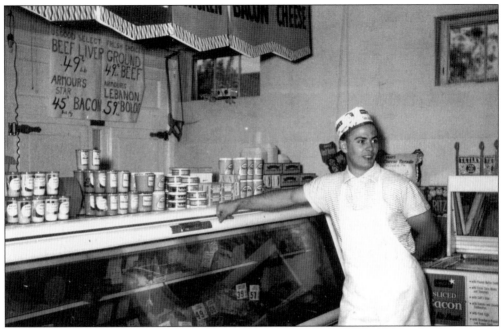

Earl Leckron, a lifelong resident of State Line, and his wife, Jean, became the owners of Earl's Market in June 1952. Earl's was known for country-cured hams and wheel sharp cheese. Farmers traded fresh eggs and garden produce for groceries. In 1996, after 45 years of service to the community, the Leckrons retired and sold the business to Joe Leskow, their former meat salesman. (Courtesy of the Middleburg–Mason-Dixon Historical Society.)

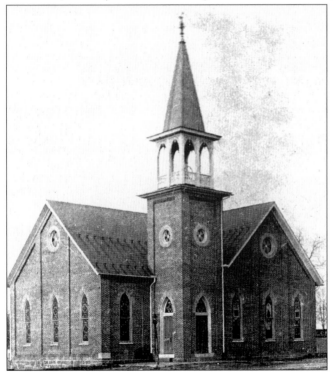

Located on the northeast corner of the square, the Union Church, built in 1834, was the first church constructed in Middleburg by the German Reformed and the Lutherans, who then shared the building for services. The current Trinity United Church of Christ was known as the Trinity Reformed Church at the time of this 1905 photograph. The United Brethren in Christ Church was built in 1843, and the Trinity United Brethren in 1892. (Courtesy of the Middleburg–Mason-Dixon Historical Society.)

Four
BUSINESS AND INDUSTRY

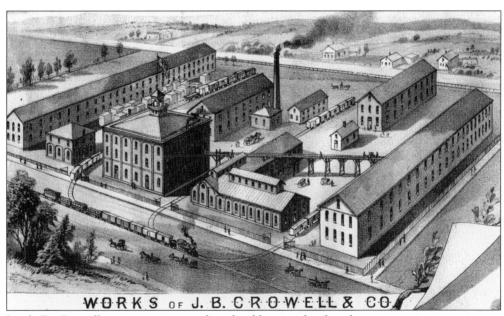

WORKS OF J. B. CROWELL & CO.

Jacob B. Crowell—construction worker, bricklayer, schoolteacher, inventor, entrepreneur, industrialist, and businessman—came to Greencastle-Antrim in 1836. His industrial journey, like that of many others, changed America. No longer were life's necessities made in small craft shops. This lithographic illustration shows the two-acre Crowell complex, Greencastle's first industrial park. It was located between South Washington Street, Cedar Lane, and Leitersburg Pike. Only two of the buildings remain. (Courtesy of Robert Kugler.)

During the mid-1800s, George Ilginfritz's woolen mill was a major employer in town. It was located at the end of North Carlisle Street and was powered by Moss Spring. Farmers brought their wool here to be carded before it was taken home again to spin. The mill also wove woolen material for purchase. This photograph shows one of the buildings in the Ilginfritz complex. (Courtesy of Lloyd "Sonny" Rowe.)

Gideon and Joseph Rahauser, leading businessmen during the late 1800s, operated a large apple-orchard business and imported draft horses from the West and stabled them in the barn on the family property at 327 East Baltimore Street. They sold the horses to special customers in the area and to buyers from Philadelphia, Baltimore, and Washington, D.C. They also bred trotters for harness racing. (Courtesy of Richard H. Gingrich.)

One generation later, Wilbur Rahauser, the nephew of Gideon and Joseph, is seen here at the limestone and frame barn that was used for the stabling of livestock. This structure also served as the sales stable for his uncles' draft-horse business in the late 1800s. The packing house for the apple orchard was located a short distance southwest. (Courtesy of Richard H. Gingrich.)

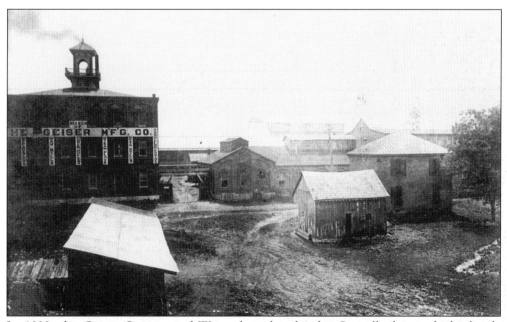

In 1899, the Geiser Company of Waynesboro bought the Crowell plant—which already included a foundry, a pattern house, and steam-powered machinery—from Rahauser, Shank, and Chamberlin. Geiser used the Greencastle plant for producing steam-driven farm engines, its specialty. In this part of the United States, Geiser was one of the first companies to manufacture gasoline-powered engines, the invention that changed not only our country but also the world. (Courtesy of Travel Centers of America.)

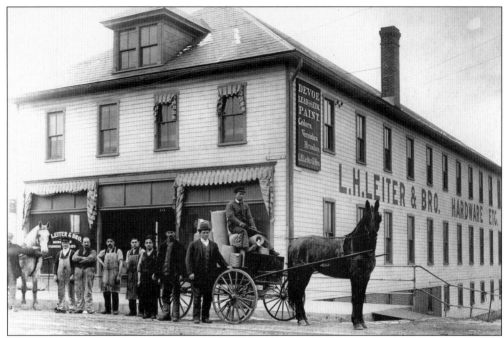

Founded in February 1904, L. H. Leiter Hardware was a family business located at 103 South Carlisle Street. This building was built by the Leiters in 1909. In this *c.* 1910 photograph, L. H. Leiter, one of the partners, stands by the front wheel of the wagon. The black horse and wagon, which were used for deliveries, were the last ones they owned. (Courtesy of Fred Schaff.)

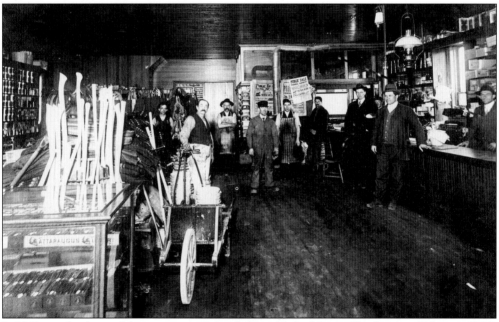

L. H. Leiter (in front of the counter to the right) established Leiter Hardware in February 1904. It eventually became the oldest International Harvester dealership in the United States. This interior photograph, taken the same day as the exterior, includes L. H.'s brother William (behind the counter), who was a business partner at the time. (Courtesy of Fred Schaff.)

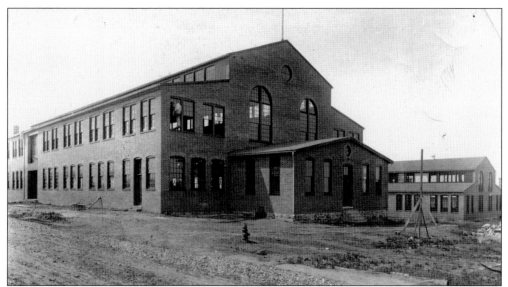

Fred T. Flinchbaugh built this branch of his York company along South Cedar Lane and Leitersburg Road in 1914. The manufacturing complex included a foundry, a machine shop, a power plant, and a warehouse. Beginning in the early 1920s, it was used by Landis Tool Company until 1944, when A. R. Warner & Son purchased it. (Courtesy of the Lilian S. Besore Memorial Library.)

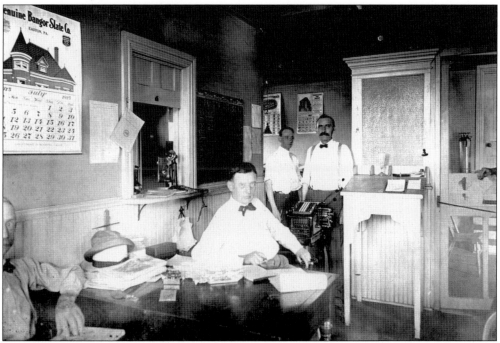

Chalmers Omwake, a partner with his brother James Edward in the business of Omwake Brothers, is seated at the desk inside the office. The calendars are dated July 1915. Modern conveniences included candlestick telephones and fire extinguishers. Omwake Brothers eventually evolved into the current business of the Antrim Building and Farm Supply Company at 201 North Carlisle Street. (Courtesy of Jean Oliver Reymer and Robert C. Reymer Jr.)

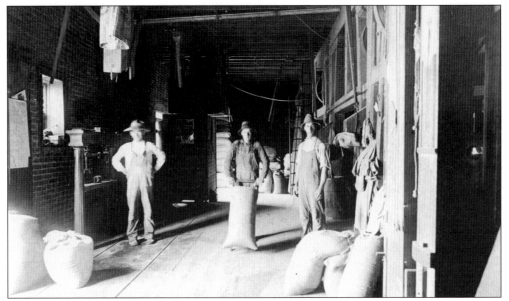

These three employees of Omwake Brothers, including Dave Fitz on the right, worked in the mill where the grinding, mixing, and bagging of grains took place. A filled bag of grain on the bag wagon is ready to be stacked in the back room with the others waiting for sale. This photograph was taken c. 1915. (Courtesy of Jean Oliver Reymer and Robert C. Reymer Jr.)

By 1938, Omwake Brothers had become Omwake and Oliver. Even in 1938, farmers still brought their grain into town by wagon, pulled onto the Fairbanks scales, weighed everything, and then weighed the vehicle alone afterward to get the accurate amount of grain brought for sale. From left to right are Omer Grosh, driver; Joshua E. Oliver, business partner; William McDonald; and Howard Stickell. (Courtesy of Jean Oliver Reymer and Robert C. Reymer Jr.)

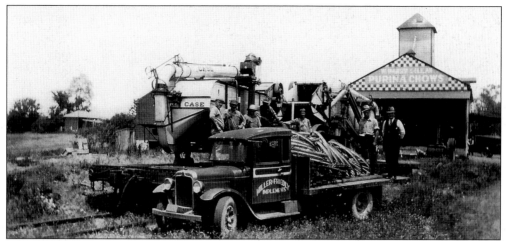

At the freight yard on South Carlisle Street, a Miller-Friedly Implements truck is loaded with large wagon-like wheels. Behind the truck, two Case threshing machines sit on the flatbed railroad car on which they rode into town. The familiar Purina Chow logo is on the gabled end of the building, with the name W. Harry Gillan above it. Today, the American Legion is located to the left. (Courtesy of Lloyd "Sonny" Rowe.)

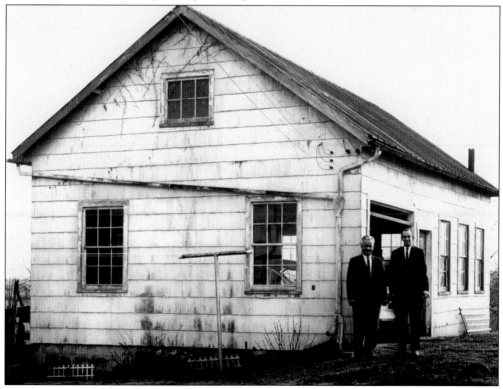

On January 1, 1947, John L. Grove, his brother Dwight L., and Wayne Nicarry signed a handwritten agreement as co-founders of a new business: Grove Manufacturing Company. Dwight (left) and John (right) stand by the rented two-car garage in Shady Grove where they started producing rubber-tired farm wagons. Since that day in January 1947, the little business has grown into an internationally known leader in hydraulic cranes. (Courtesy of Grove Worldwide.)

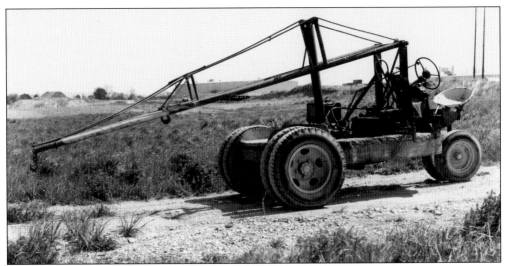

After establishing their business, Grove Manufacturing Company owners realized they needed some type of machine to lift and move the heavy steel plates used to manufacture their wagons. This was one of the first cranes they designed to meet their needs. Soon their wagon customers inquired about where they could purchase the cranes. Shortly after, the cranes were added to Grove's product line, and the rest is history. (Courtesy of Grove Worldwide.)

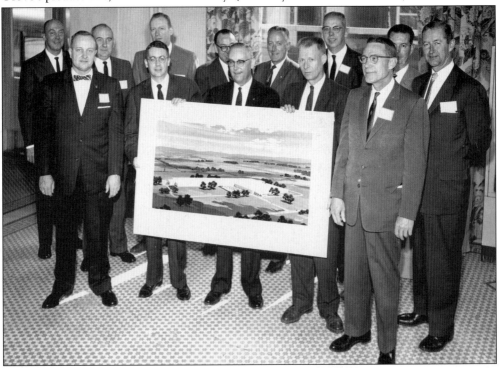

This group of men announced to the public on February 24, 1960, that Corning Glass Works would build a new plant in Greencastle-Antrim. Two men played key roles in the negotiations: A. G. Crunkleton (center, behind the illustration) and C. Vernon Stone of Potomac Edison's area development department (front row, right). Work began immediately, and the plant opened on June 20, 1960. (Courtesy of World Kitchen.)

Five
PUBLIC SERVICES
AND TRANSPORTATION

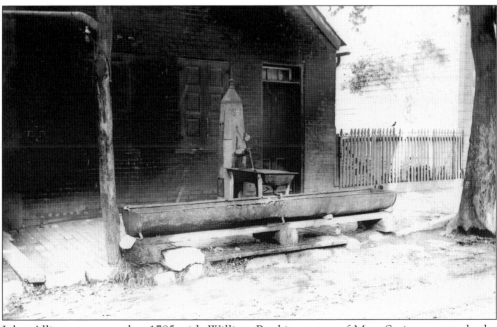

John Allison contracted *c.* 1785 with William Rankin, owner of Moss Spring, to supply the town with water that was carried through wooden troughs. Later, the troughs were improved, and public cisterns were used for fire protection. Public wells like Hartman's, located at 42 East Baltimore Street, were used by the townspeople for domestic needs and watering horses while traveling. (Courtesy of Frank H. Ervin.)

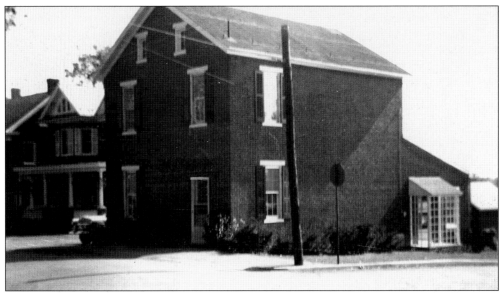

Greencastle's toll gatehouse for the Waynesboro-Greencastle-Mercersburg Turnpike was located at 409 East Baltimore Street. The gatehouse shown here was not the one operating when the turnpike opened in 1840, but it is in the original location. The gatehouse was moved a couple blocks east when the borough limits were extended in the early 1900s, but this building remained the gatekeeper's house. (Courtesy of Gladys Dentler.)

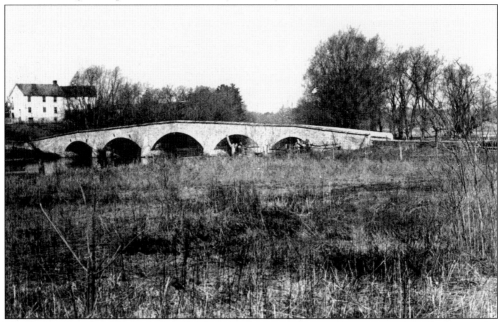

The five-arch limestone bridge was built c. 1830, about 12 years after construction began on the Waynesboro-Greencastle-Mercersburg Turnpike. It spanned the Conococheague Creek 200 feet south of Route 16. It was the only bridge of its kind in Franklin County. The home belonged to Henry Lesher. Contrary to popular belief, Hurricane Agnes in 1972 did not destroy the bridge. The Pennsylvania Department of Transportation needed road fill and chose to dismantle the bridge shortly after Agnes. (Courtesy of Oliver Goetz.)

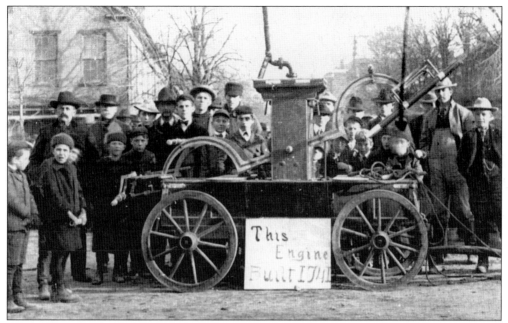

An ordinance was passed in 1831 requiring all white male residents to enroll in the Greencastle Fire Company. They were obligated to attend training sessions the first Wednesday of each month. In 1838, the *c.* 1741 hand pumper was purchased from Baltimore. Bucket brigades and the hand pumper were used until 1883, when a more efficient Silsby steam-powered machine was bought. The Rescue Hose Company was formed in 1896. (Courtesy of the Rescue Hose Company.)

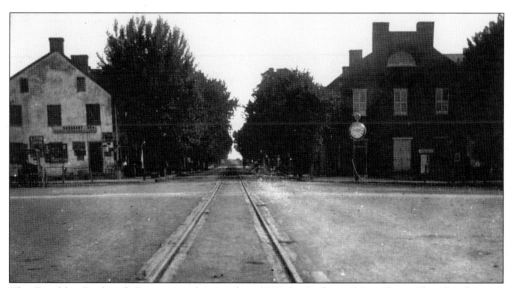

The Franklin Railroad Company, chartered *c.* 1837, built the rail line from Chambersburg to Hagerstown. Greencastle's rail service began in 1839. In 1865, the Franklin Railroad merged with the Cumberland Valley Railroad Company to become the Cumberland Valley Railroad. T. C. McCullough, of Greencastle, served as its first president. The Cumberland Valley Railroad then became part of the Pennsylvania Railroad Company in 1918. (Courtesy of Lloyd "Sonny" Rowe.)

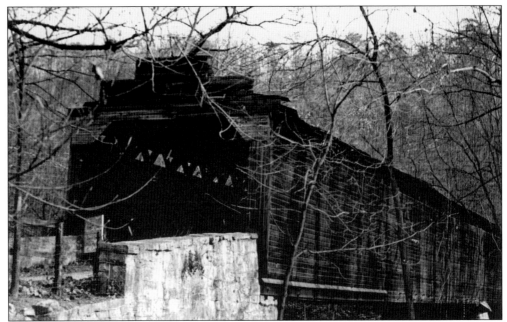

Martin's Mill covered bridge, spanning 200 feet, was built in 1849 as a crossing point on the Conococheague Creek to connect the road from Upton to the Williamsport Pike. In 1972, the floods from Hurricane Agnes swept it off its foundation. The Martin's Mill Bridge Association was established to save the bridge through reconstruction. Antrim Township assumed ownership of the bridge in December 2003. (Courtesy of the Allison-Antrim Museum.)

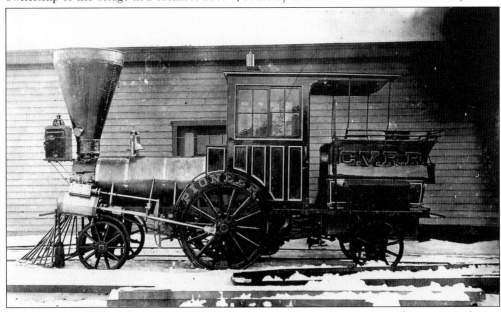

Built by Seth Wilmarth of Boston, the *Pioneer*, a lightweight passenger locomotive, began service in 1851 and operated on the Cumberland Valley Railroad route between Harrisburg and Hagerstown. Weighing 20,000 pounds, it was used for passenger service from 1851 to 1876. After that, it was used for construction train service until 1890. Deemed a historic relic in 1901, the locomotive was given to the Smithsonian Institute in 1960. (Courtesy of Lloyd "Sonny" Rowe.)

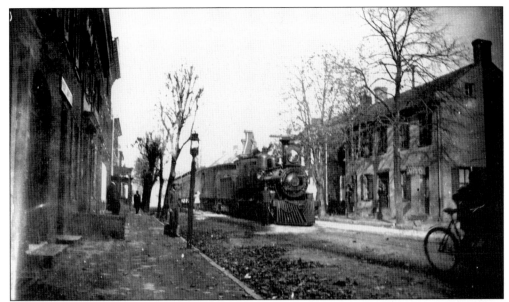

It is hard to imagine the great iron horse running through the middle of Greencastle seven times each day in both directions, as was the schedule from the late 1800s to the early 1900s. The railroad changed the pace of America, enhanced commerce, increased the prosperity of the nation, and created tourism. It allowed Jacob Hostetter to bring fresh seafood from Chesapeake Bay to Greencastle in half a day. The train in this picture heads south on North Carlisle Street. (Courtesy of the Allison-Antrim Museum.)

In 1888, a two-story brick building that served as the engine house was constructed at 60 North Washington Street for use by the fire company. In 1895, the town council moved into an upstairs office. The fire company moved to 48 South Carlisle Street in 1948 and remained there until the former South Antrim Elementary School building at 842 South Washington Street was purchased in 1995. The headquarters are now in that building. (Courtesy of the Rescue Hose Company.)

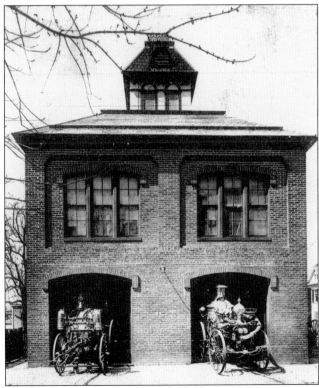

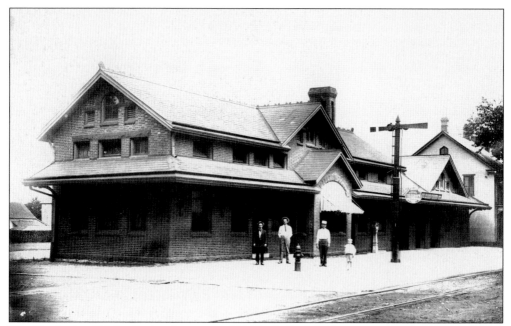

The Cumberland Valley Railroad station at 100 North Carlisle Street opened for passenger service in 1900. It was the first Cumberland Valley Railroad station specifically built for passengers. The first stops had been at the northwest corner of the square and Baltimore Street and at the 35 North Carlisle Street station. Shown in this photograph, from left to right, are George Shrader, Charlie Gardner, Bert Yates, and an unidentified boy. (Courtesy of P. Sean Guy.)

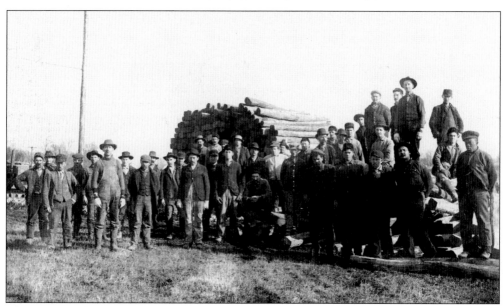

The Greencastle section of the Chambersburg, Greencastle, & Waynesboro Street Railway Company was built first in order to connect to the Hagerstown trolley line, which was already in operation. The rails were laid in November and December 1903. The first trolley car entered Greencastle at 3:30 p.m. on December 17, 1903. Some of the men who laid the lines are shown here. (Courtesy of A. Richard Walck.)

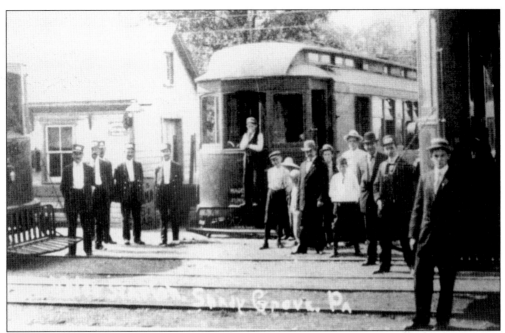

The Greencastle, Waynesboro, and Hagerstown trolleys are all parked at Union Station, the junction of the three lines in Shady Grove. The Hagerstown line approached Shady Grove from the south and ended along the east side of what is now the Shady Grove post office. The Union Station ticket office was the small, white building beside the Hagerstown tracks on the east side. (Courtesy of Frances "Pickle" Diehl.)

The Greencastle Light, Heat, and Power Company was formed in 1905. From this building on West Franklin Street, energy was generated for the borough. Although given a 99-year right to furnish power to private residents, the company became a subsidiary of the Republic Service Corporation in 1926. Potomac Edison acquired ownership in 1946. (Courtesy of the Lilian S. Besore Memorial Library.)

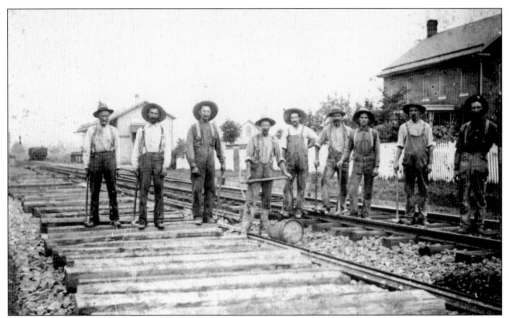

Nine men lay a second rail line on North Carlisle Street *c.* 1905. The Carlisle Street tracks serviced businesses in the northern and southern parts of town until 1936, when they were removed through a federal works project during the Depression. The brick house in the background is no longer standing. The sixth man from the left is George Shatzer. (Courtesy of Bonnie Bingaman.)

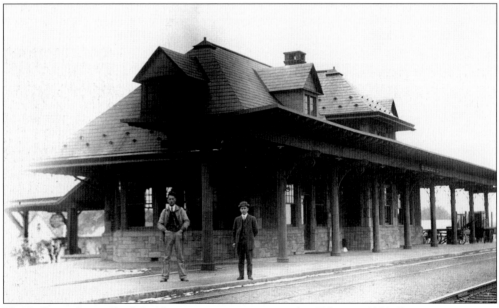

The Jefferson Street "high line" passenger station opened in February 1909. Because passengers now had farther to go to get to their hotels after departing the train, each hotel provided transportation for its guests. Hotel employees were kept busy loading and unloading baggage carts, a common scene on the streets in that era. George P. Shrader appears on the right. (Courtesy of the Allison-Antrim Museum.)

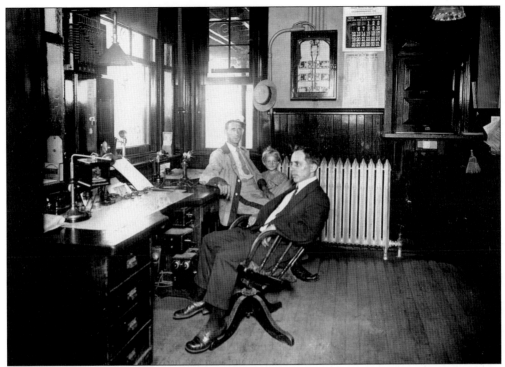

George P. Shrader (foreground) worked for the railroad for 50 years. He ran the controls at the Marion Signal Station and was the ticket agent in town. Shrader, the baggage handler, and the child are in the ticket agent's office at the Jefferson Street station in July 1915. Note that there are at least three candlestick telephones on the desk and window sill. (Courtesy of the Allison-Antrim Museum.)

These women were mostly identified by their phrase, "Number please." Shown here *c.* 1930, from left to right, are Ruth Cump Smith, Viola Barnhart, and Viola "Ollie" Cump, chief operator for 40 years. They worked for the United Telephone Company when the switchboards were located upstairs at 21 East Baltimore Street, as well as when the operation moved to 45 East Baltimore. Greencastle's first telephone circuit connected Carl's Drug Store and the Carl residence in 1896. (Courtesy of Ollie Smith.)

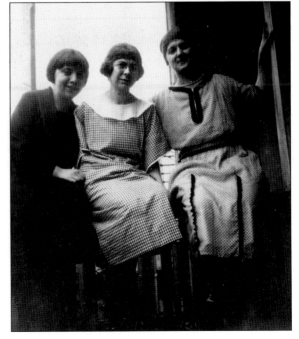

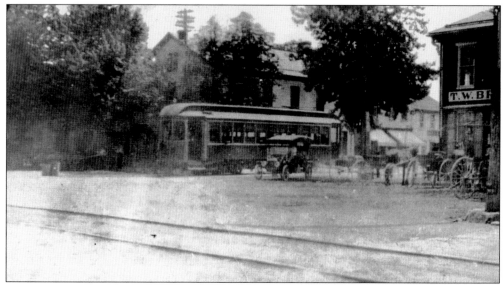

The last trolley car left Greencastle on Saturday, January 16, 1932, at 9:45 p.m. Car No. 33 was in the charge of motorman John Flautt and conductor Harbaugh. Central in this photograph is the horseless carriage, which prompted the demise of the horse-and-buggy and trolley days and the decline of the railroad. Passenger service ceased in Greencastle, and the trucking industry severely affected freight hauling. (Courtesy of Lloyd "Sonny" Rowe.)

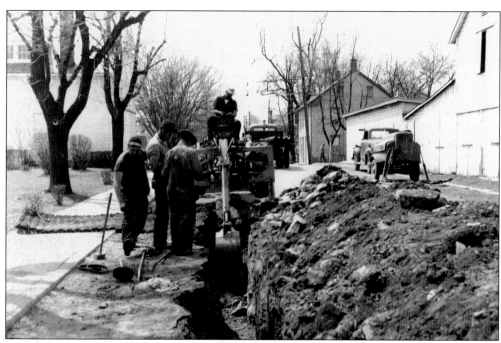

In the summer of 1957, after much controversy (mostly over the dollar amount of quarterly billings and connection fees), the borough's sewer system was begun. It became a necessity, at the urging of the state, because the Conococheague Creek and underground streams were being polluted from food-processing plants in town. New water lines were also installed during the lengthy project. (Courtesy of World Kitchen.)

Six

CARL'S DRUG STORE

Made in New York City, glass slides, such as this one for Carl's Drug Store, were used as advertisements in movie theaters. The image was shown on the screen with the use of a special slide projector. The set of Carl's slides includes one colored and three black-and-white slides. These were likely used at the Gem Theater. (Courtesy of the Allison-Antrim Museum.)

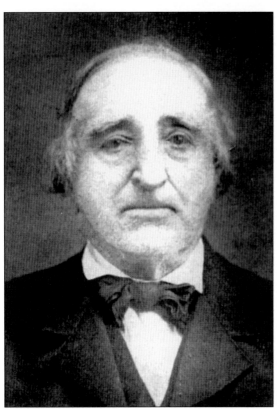

Dr. Adam Carl was born on December 16, 1800, and died in April 1891 at the age of 90. He was born in Hanover, York County, and was raised by an uncle after his father died. As a young man, Carl traveled to Carlisle to work as a clerk in an apothecary shop. It was during this time that he became interested in medicine. (Courtesy of the Franklin County Medical Society.)

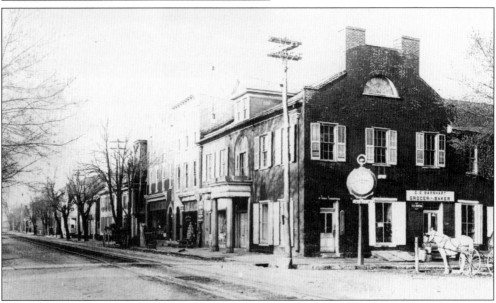

Adam Carl came to Greencastle in April 1825 and opened a drugstore at 13 South Carlisle Street. Carl's Drug Store is now the oldest continuously operating drugstore in the United States. It was owned by three generations of the Carl family until it was sold in 1974 to Frank H. Ervin. In this photograph from a later time, 13 South Carlisle Street is the third building from the right. (Courtesy of the Allison-Antrim Museum.)

Adam Carl graduated from Washington Medical College in Baltimore, Maryland, in March 1829, after studying under his mentor, Dr. James Henry Miller. Sometime that same year, Carl moved his drugstore to 27 South Carlisle Street. This house later became the Pitt F. Carl residence. (Courtesy of Lloyd "Sonny" Rowe.)

In 1833, Adam Carl acquired the title to the property at 27 North Carlisle Street and, in 1836, built the house on the right, which served as both a residence and a drugstore. Dr. Carl decided to go back to practicing medicine full-time in 1854. The drugstore entrance was the door on the right of the building. The building on the left is the Citizens Bank. (Courtesy of the Allison-Antrim Museum.)

In 1854, Dr. Carl's son William took over management of the store until he died suddenly in 1874. Dr. Carl then hired his grandson Charles as his assistant. While Charles was studying at the Philadelphia College of Pharmacy, from which he graduated in 1880, Dr. Franklin A. Bushey, a son-in-law, managed the business. Dr. Bushey (left) and Charles (right) pose for this *c.* 1880 photograph. (Courtesy of the Allison-Antrim Museum.)

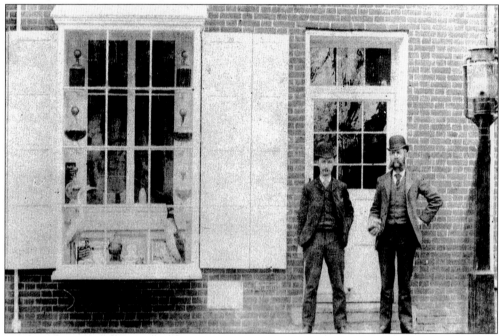

After graduating from pharmacy school, Charles Blair Carl (left) took over the operation of the drugstore while the 80-year-old Dr. Carl continued to practice medicine. Charles purchased the business in 1888, becoming the second Carl generation to own the store. Note the new street lamp in this *c.* 1890 photograph in comparison to the earlier light fixture in the previous picture. Dr. Franklin Bushey is shown on the right. (Courtesy of the Allison-Antrim Museum.)

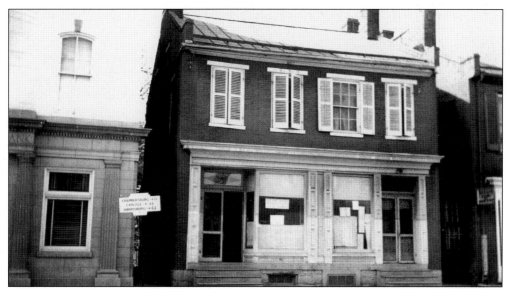

Dr. Adam Carl died in April 1891. In May 1891, Charles moved the store across the street to 6 North Carlisle, next to the First National Bank where his father, John, had once operated a boot and shoe store. The entrance to the family's residence was on the south side of the building near the back. The drugstore was on the left, and C. S. Phipps confectionery was on the right. (Courtesy of the Allison-Antrim Museum.)

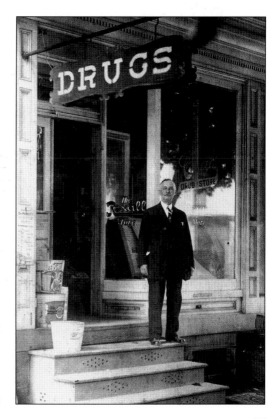

In this 1915 photograph, Charles B. Carl stands on the steps of the 6 North Carlisle Street store, which was next to the First National Bank. One year later, Charles moved the store to the new three-story brick building that he constructed at 6 East Baltimore Street. The electric drug sign seen here is on permanent exhibit as part of the Carl Collection at the Allison-Antrim Museum, and it still works. (Courtesy of the Allison-Antrim Museum.)

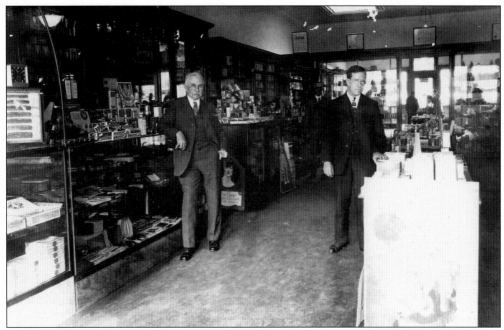

Charles B. Carl stands at the glass counter inside the East Baltimore Street store in January 1930. This view from the front of the store looks north. The back wall of the store at that time was covered in mirrors, making the two unidentified gentlemen and the photographer look as though they are leaving the store. (Courtesy of the Allison-Antrim Museum.)

When Charles B. Carl died in 1935, Edward Rhodes Carl (seen here), his youngest son, assumed management of the business. Upon the death of his mother, he became the owner and the third and last Carl generation to own the store. On January 1, 1974, Edward sold the business to Frank H. Ervin. On March 8, 1999, Ervin moved the drugstore to 145 North Antrim Way. (Courtesy of the Allison-Antrim Museum.)

Seven

CIVIL WAR VETERANS

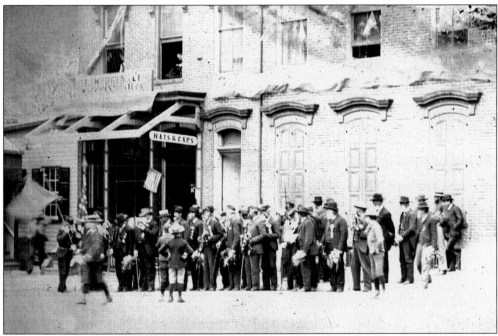

This photograph of the Grand Army of the Republic (GAR) Corporal Rihl Post No. 438 shows the veterans organizing on the northwest corner of the square. They have bouquets of flowers in their hands to place on the graves of their dead comrades. Taken from one of the couple-hundred glass-plate negatives of George F. Ziegler, this image dates to the late 1800s. (Courtesy of the Allison-Antrim Museum.)

Henry Bartle, the great-great-grandfather of Bonnie Bingaman, was mustered into Company K, 126th Pennsylvania Volunteers, as a private on August 2, 1862, and was mustered out on May 20, 1863. He re-enlisted as a corporal in Company K, 21st Pennsylvania Cavalry, and served from July 25, 1863, to July 8, 1865. For almost six months, he and John T. Koons of Antrim Township were both soldiers in that same company. (Courtesy of Bonnie Bingaman.)

Dr. Franklin Bushey, a surgeon in the 4th Pennsylvania Cavalry, was a prominent physician in the Greencastle-Antrim area. He was one of the most active veterans of GAR Corporal Rihl Post No. 438. Dr. Bushey was involved in the organization of the annual Memorial Day ceremonies and in the fund-raising for the Corporal Rihl monument. He married Mary Ellen Carl, the youngest daughter of Dr. Adam Carl. (Courtesy of the Franklin County Medical Society.)

Col. William H. Davison was born in Antrim Township on November 2, 1836, and died on September 8, 1875. Davison enlisted with Company B, 126th Pennsylvania Volunteers, and was commissioned captain on October 8, 1862. Gov. John W. Geary commissioned him colonel in 1870. Davison was in charge of collecting volunteers from Antrim Township, who, along with volunteers from Fulton County, comprised Company B. He was the great-grandfather of William Davison Elden. (Courtesy of William D. Elden.)

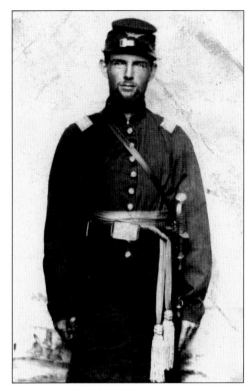

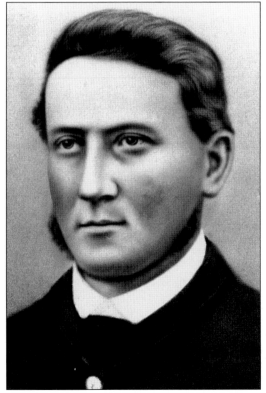

Sgt. Jacob A. Finfrock of Antrim Township, Company D, 209th Pennsylvania Infantry, served with distinction at the battles of Petersburg, Fort Stedman, and Fort Mahone. After the war, he farmed in Antrim Township and owned one of the prime peach-and-apple orchards in the area. Finfrock was the expert on fruit production in the county. He was also the great-grandfather of Frank H. Ervin. (Courtesy of Frank H. Ervin.)

Francis Hoffman enrolled on January 27, 1863, in Company H, 2nd Artillery, 112th Pennsylvania Volunteers. He mustered out on April 9, 1865, at the age of 18, because his left leg had been amputated above the knee due to a gunshot wound received in the battle of Petersburg on June 18, 1864. He lived at 50 West Madison Street with his wife, Urilla, until his death on July 18, 1925. (Courtesy of George Hoffman.)

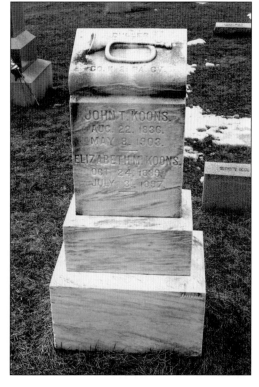

John T. Koons of Antrim Township was born on August 22, 1830, and died on May 8, 1903. Koons served two enlistments, both as bugler. He mustered into Company C, 2nd Regiment, Pennsylvania Volunteers, on April 20, 1861, and mustered out on July 26, 1861. Koons then enlisted in Company K, 21st Pennsylvania Cavalry, on August 1, 1863, and mustered out on February 20, 1864. Note the bugle on top of the headstone. (Courtesy of Kenneth Shockey.)

Jasper McLanahan of Antrim Township was the grandfather of Dorothy Crunkleton Statler of Greencastle. This small tintype shows Jasper in very fashionable gentlemen's attire after the Civil War. Jasper was a farmer who lived on the Milnor Road and owned two farms. He was married twice and raised 12 children. (Courtesy of the Allison-Antrim Museum.)

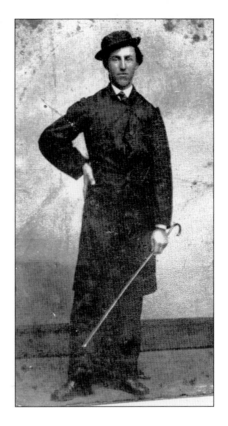

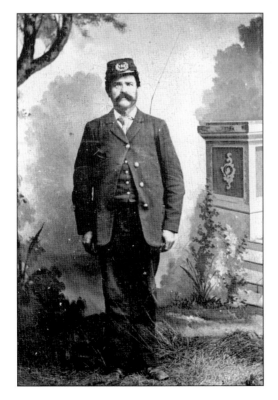

George Snively, the son of the founder of Shady Grove, Melchi Snively, was born at the family homestead. After attending school in Mercersburg for two years, he enlisted in the 17th Pennsylvania Cavalry on October 12, 1862. He was mustered out on October 7, 1865. Snively was active in the GAR Corporal Rihl Post No. 438 in Greencastle. (Courtesy of the Allison-Antrim Museum.)

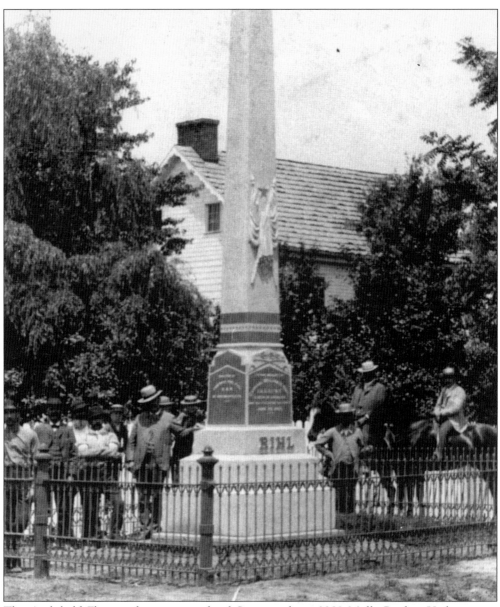

The Archibald Fleming farm just north of Greencastle at 9389 Molly Pitcher Highway was where, in an ambush by the Confederates on June 22, 1863, Corp. William H. Rihl, Company C, First New York (Lincoln) Cavalry, became the first Union soldier killed north of the Mason-Dixon Line. The Confederates buried Rihl in a shallow grave. A few days later, a group of citizens disinterred his body, placed it in a coffin, and reburied him in the Lutheran cemetery. Rihl's body was reinterred on June 22, 1886, at the site of his death, which is also the site of this monument. The granite monument, funded by the Corporal Rihl Post and a $500 appropriation from the state legislature, was erected and dedicated on June 22, 1887. Local GAR members are shown here as they gathered at the monument, which is located at the Fleming farm along Route 11. The Fleming family and its descendants have owned this property for five generations. (Courtesy of the Helen Welch family.)

Dr. George Davidson Carl, the son of Dr. Adam Carl, tended to the wounded leg of Sgt. Milton Cafferty, the second Union soldier shot during the Confederate ambush at the Fleming farm on June 22, 1863. Cafferty was moved to the Ilginfritz home on North Carlisle Street near the borough limits, where he was cared for until he recovered. He returned to his regiment in mid-July. (Courtesy of the Allison-Antrim Museum.)

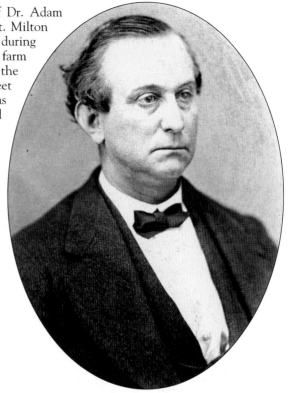

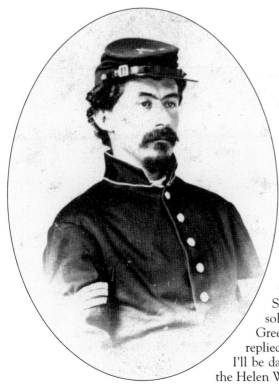

Sgt. Henry Strickler of Greencastle enlisted in Company K of the 126th Pennsylvania Volunteers. Losing his left arm at the battle of Fredericksburg, he was discharged on April 27, 1863, after being released from the Findlay Hospital in Washington. A few months later, Strickler was confronted by a Confederate soldier marching to Gettysburg through Greencastle who wanted his new hat. Strickler replied, "You took my arm at Fredericksburg, but I'll be damned if you'll take my hat." (Courtesy of the Helen Welch family.)

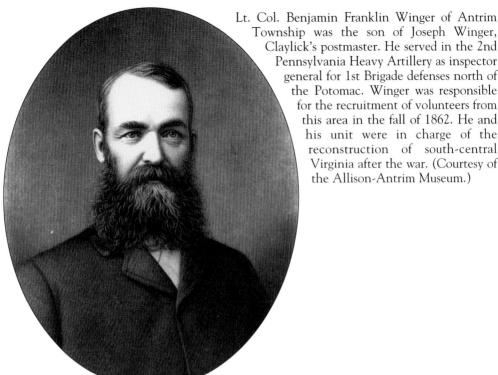

Lt. Col. Benjamin Franklin Winger of Antrim Township was the son of Joseph Winger, Claylick's postmaster. He served in the 2nd Pennsylvania Heavy Artillery as inspector general for 1st Brigade defenses north of the Potomac. Winger was responsible for the recruitment of volunteers from this area in the fall of 1862. He and his unit were in charge of the reconstruction of south-central Virginia after the war. (Courtesy of the Allison-Antrim Museum.)

The Grand Army of the Republic Corporal Rihl Post No. 438 was organized on May 12, 1884. Its first endeavor, on May 30, 1884, was the sponsorship of Decoration Day, which had been started on May 30, 1868, as Memorial Day to honor the Civil War veterans. Corporal Rihl Post members enter the square on May 30, 1889, after returning from ceremonies at Cedar Hill Cemetery. (Courtesy of Lloyd "Sonny" Rowe.)

Eight
NOTEWORTHY INDIVIDUALS

George W. Ziegler was born on April 30, 1810, and apprenticed in several general stores before coming to Greencastle in 1833. He bought part interest in a general store and then went into business with his brother David until his death on November 16, 1897. George W. was a prominent businessman, a director of the Waynesboro-Greencastle-Mercersburg Turnpike, and a founder of the First National Bank. (Courtesy of the Allison-Antrim Museum.)

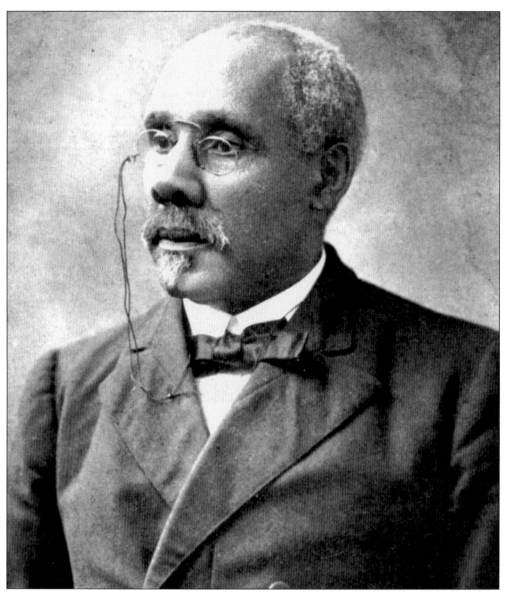

Dr. Matthew Anderson was born on January 25, 1845, the son of a Scotsman father and an African American mother. He was raised on a farm in Antrim Township and was educated in a one-room schoolhouse. The Anderson family faithfully attended the Greencastle Presbyterian Church. After the Civil War, Anderson taught at the Presbyterian College for Negroes in Salisbury, North Carolina, until 1874. In 1877, he made history as the first African American to graduate from the Princeton Theological Seminary. Anderson earned his doctorate at the Yale Divinity School and was ordained by the Carlisle Presbytery on June 12, 1878. He served as pastor of the Berean Presbyterian Church in Philadelphia from 1880 until he died on January 11, 1928, 14 days shy of his 83rd birthday. During his pastorate in Philadelphia, he established trade schools for African Americans, enabling them to earn a living for themselves. The Berean Building and Loan Association, also founded by Anderson, gave African Americans a source of funding with which to purchase their own homes. Anderson's life accomplishments lifted him to national renown. (Courtesy of the Lilian S. Besore Memorial Library.)

George Frederick Ziegler of Greencastle, born on February 2, 1843, was educated in local schools and was tutored privately. He served in Company K, 126th Pennsylvania Volunteers, and fought at Fredericksburg and Chancellorsville. After extensive studies at Amherst, Princeton Theological Seminary, and abroad, George F. returned to Greencastle and opened a private school. Later, he concentrated on his father's numerous business interests, his own farms, and his glass-plate photography. (Courtesy of the Allison-Antrim Museum.)

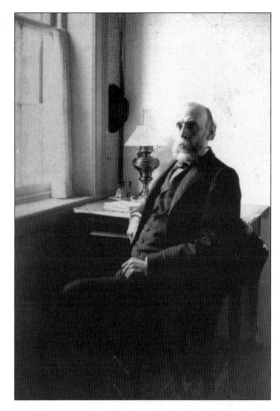

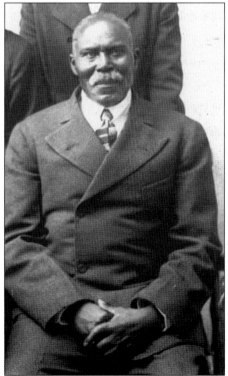

Samuel Houston Rankin, born into slavery in Tennessee, was freed by Union troops at the age of 10. During his journey north by horse, he managed to avoid detection and capture by the Confederates. Rankin eventually made his way to Greencastle and decided to stay. He was highly respected in the community and was deeply mourned upon his death at 85 years of age. (Courtesy of Jackie Dixon.)

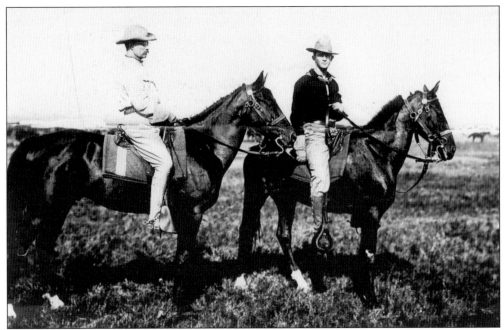

Henry Prather Fletcher, born on April 10, 1873, was a native son raised in Greencastle. Fletcher's political connections began when, through persistence, Theodore Roosevelt accepted him as one of his Rough Riders during the Spanish-American War. In January 1898, he fought at San Juan and El Caney, Santiago de Cuba. Fletcher is shown here with Theodore Roosevelt during his time with the Rough Riders. (Courtesy of Lloyd "Sonny" Rowe.)

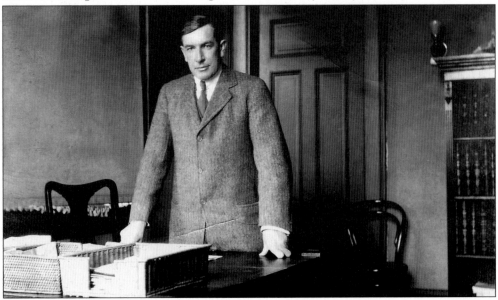

Fletcher served 51 years under eight presidents (from Theodore Roosevelt to Harry Truman) as a U.S. ambassador to four countries and held various secretarial positions with legations in three countries. He was ambassador to Chile, Mexico, Belgium, and Italy. The secretarial positions were in Cuba and Portugal and twice in China. Pres. Herbert Hoover was a guest at Rosemont, Fletcher's summer home in Greencastle. (Courtesy of Lloyd "Sonny" Rowe.)

Emily L. Fletcher was the wife of Pitt Carl. She graduated from Wilson College in the class of 1887 and became very involved in social, civic, and church functions. She attended the Presbyterian church, participated in the Franklin County Daughters of the American Revolution, and helped lead the restoration of the Brown's Mill Cemetery. Emily was the sister of Henry P. Fletcher. She died on December 28, 1935. (Courtesy of Wilson College.)

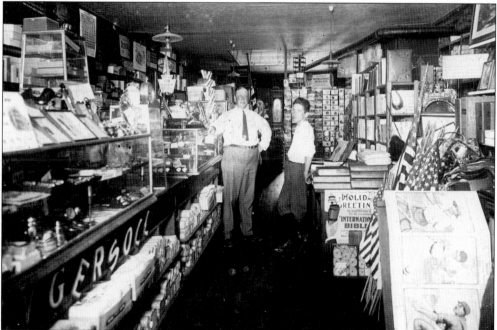

Pitt Carl, the brother of Charles B. Carl, is shown inside his establishment at 8 Center Square on July 20, 1915. Pitt hired many young gentlemen and women as clerks in the store and often paid for their higher education. The bookstore was always the headquarters for reminiscing. Pitt published the many famous town postcards that are very collectible today. He died on June 11, 1933. (Courtesy of the Allison-Antrim Museum.)

Sadie Rankin, the daughter of Samuel and Bettie Gaven Rankin, lived at 45 West Franklin Street. She is always described as one of the nicest ladies in town and readily helped anyone in need. Sadie was employed by Henry P. Fletcher at his home on South Allison Street but also worked for Dorothy Guenon, Dr. William Guenon's wife. (Courtesy of Jackie Dixon.)

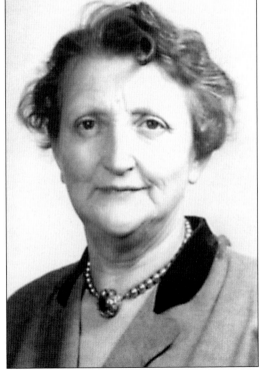

Pearl Henneberger Gingrich was born on December 12, 1891, in Clay Hill. She graduated from the Shippensburg Normal School in 1911. Pearl began her 44-year teaching career at Bushtown's one-room schoolhouse. She taught solely in one-room schools until her retirement from South Antrim in 1956, the year after the one-room schools closed. She married Howard Gingrich Sr. and had five children. Pearl died in 1993. (Courtesy of Marie Louise Gingrich.)

Carter Warren "Mose(s)" Rankin was the son of Samuel and Bettie Rankin. Upon enlistment in World War I, he was appointed the leader of the Greencastle draftees while on the way to Camp Green, North Carolina. Mose worked for Landis Machine in Waynesboro as a custodian and always enjoyed working on cars in his garage. He died in 1976, the last surviving child of Samuel Houston Rankin. (Courtesy of John T. Conrad III.)

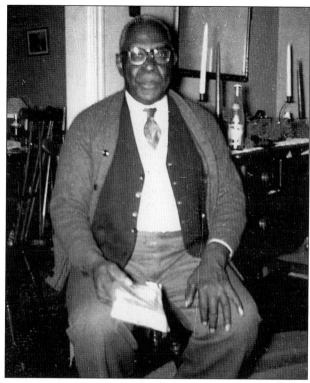

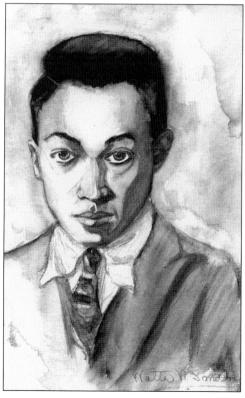

Walter Washington Smith was born in 1887 and died in 1950. A graduate of the Carnegie Institute of Fine Art, Smith became internationally known and won wide acclaim for his paintings of Greencastle and Antrim Township. Smith's paintings were exhibited in museums, universities, institutions in Paris, and art galleries, including the Corcoran Gallery in Washington, D.C. A collection of 15 of his paintings is on exhibit at the Allison-Antrim Museum, along with this 1915 self-portrait. (Courtesy of the Allison-Antrim Museum.)

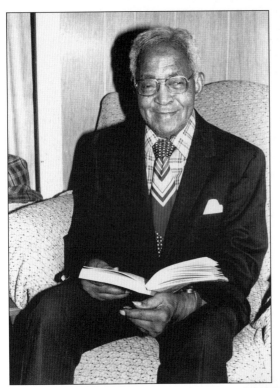

George Hamilton was born in Clay Hill on March 8, 1889. He was an active member of the Bethel American Methodist Episcopal Church. Hamilton was a porter for the McLaughlin Hotel and received the first contract with the U.S. Postal Service to deliver mail from the passenger station to the Greencastle and Mercersburg post offices. He sang often and was active in the Old Home Week Association. Hamilton died on October 24, 1984. (Courtesy of the Lilian S. Besore Memorial Library.)

George Frederick (G. Fred) Ziegler Jr. was born on December 26, 1901, and died on February 24, 1984. He was editor of the *Echo Pilot* for 53 years and owned it for 46 years. G. Fred was a member of the Greencastle Presbyterian Church, an avid naturalist, a lecturer, a member of civic organizations, an author, and a columnist for the *Record Herald*. He also wrote seven Old Home Week pageant scripts. He and his wife, Helen, had three children. (Courtesy of Mary Ziegler Glockner.)

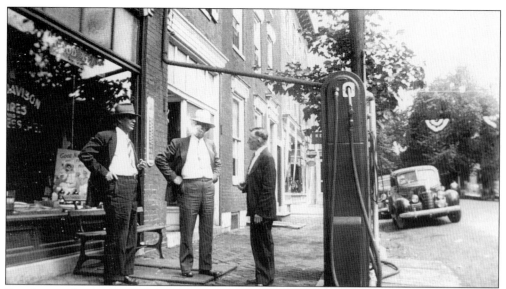

Standing in front of Billy Jim Davison's automotive store and Atlantic gas station on North Carlisle Street in this northerly view are, from left to right, Arvid Minnich, undertaker; Allen Brumbaugh, postmaster; and George Myers, part owner of Myers and Fitz Lumber Yard and Feed Elevator. The time period is the mid-1930s to early 1940s. The banners across the street indicate it may have been Old Home Week. (Courtesy of Lloyd "Sonny" Rowe.)

Gideon Rahauser (left) stands outside the limestone and frame barn, which was used for stabling livestock, with his nephew Joe, Wilbur's son. Joe was the third generation of the Rahausers to be involved with the family business. He helped manage the farms until the property was sold and, after that, he sold cattle supplies to local farmers and worked as a substitute rural mail carrier. (Courtesy of Richard H. Gingrich.)

William P. Conrad was born on December 31, 1910, and died on September 22, 1992. He served the Greencastle-Antrim School District for 42 years as an educator, administrator, and coach. Conrad was a noted historian, columnist, author of four books and several Kittochtinny papers, and member of community and civic organizations. He also attended the Greencastle Presbyterian Church. Conrad and his wife, Pearl, had one son. (Courtesy of the Lilian S. Besore Memorial Library.)

John Landis Grove was born on January 26, 1921, and died on June 16, 2003. He was an inventor, innovator, businessman, entrepreneur, philanthropist, community leader, and cofounder of two internationally known companies: Grove Worldwide and JLG Industries. Grove had endless ideas and enjoyed the challenge of bringing them to fruition. He continues to touch countless lives through the services offered at the John L. Grove Medical Center, the employment opportunities at the companies he cofounded, and the scholarship endowments to Shippensburg University. (Courtesy of Cora Grove.)

Nine
EVENTS AND PASTIMES

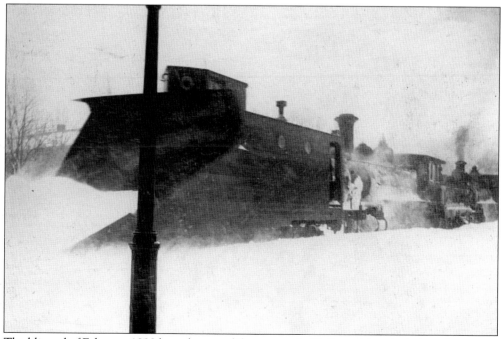

The blizzard of February 1899 brought town life to a standstill. Everything, including the square, was dug out by hand. There were no plows to open the roads. Three days after the blizzard, on February 14, the first train entered Greencastle. A wedge snowplow is being pushed by two engines in order to clear the tracks. (Courtesy of the Allison-Antrim Museum.)

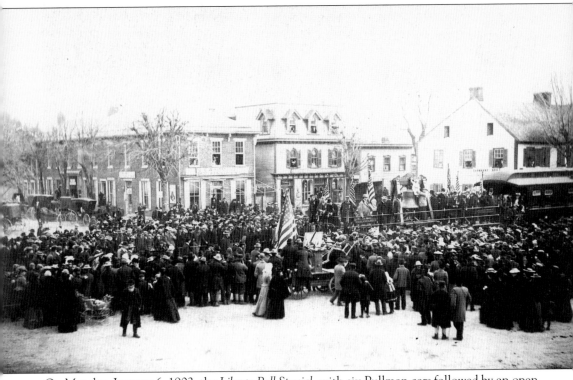

On Monday, January 6, 1902, the *Liberty Bell Special*, with six Pullman cars followed by an open car carrying the Liberty Bell, entered town from the north and stopped in the square at 2:50 p.m. Hundreds of people crowded into the square to catch a glimpse of the Liberty Bell. Thousands more people stood along the railroad tracks as the *Liberty Bell Special* made its way. It had departed from Philadelphia at 8:00 a.m. on January 6 to reach Charleston, South Carolina, for a special exhibition of the Liberty Bell on Friday, January 10. One lucky Greencastle-Antrim child, through a random drawing, got the privilege of standing on the open car by the Liberty Bell to have a photograph taken. A man lifts that small child toward the bell. Rescue Hose's *c.* 1741 hand pumper is in the center of the photograph. People are in open windows all around the square trying to see the Liberty Bell, a once-in-a-lifetime experience. The train departed Greencastle's square at 3:05 p.m. that same day. (Courtesy of the Lilian S. Besore Memorial Library.)

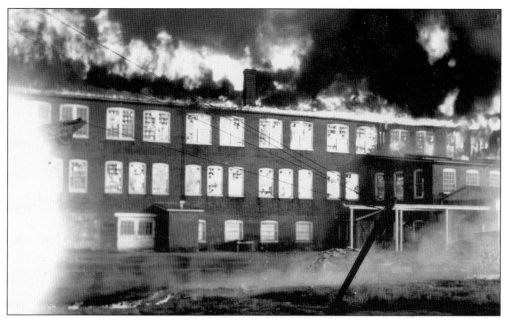

On March 8, 1945, at 6:10 p.m., the alarm sounded when the A. R. Warner & Son warehouse, where valuable World War II naval supplies were being stored, caught on fire. Spreading rapidly, the fire created an explosion that blew out the north wall, and within less than hour, only the shell of the building was standing. The warehouse was originally built by Flinchbaugh and, prior to Warner, it had been used by the Landis Tool Company. (Courtesy of Rescue Hose Company.)

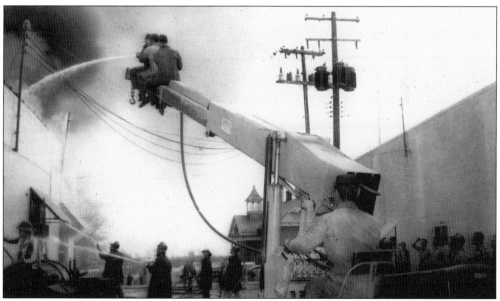

On April 28, 1960, the fire sirens sounded from mountain to mountain across the valley. At 2:20 p.m., a fire began in the paint dipping tank and spread rapidly, causing $250,000 in damage at the Grove Manufacturing Company. Not one of the 90 employees lost his or her job. Three Grove employees are on the end of the crane boom, positioned by the crane operator to the most advantageous spot for directing water on the flames. (Courtesy of Grove Worldwide.)

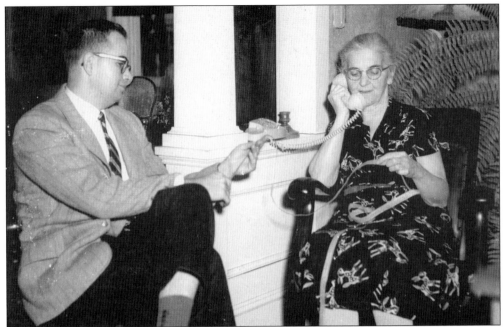

Viola Cump, who worked for the United Telephone Company for 45 years beginning *c.* 1912, was given the honor of making Greencastle's first customer-direct, distant-dialed phone call from her home. The call was made on a Sunday in February 1962 after 2:01 a.m., when the company changed from switchboard to dial service. Viola made the historic call to her brother Guy Cump, who lived in Nazareth, Pennsylvania. (Courtesy of Ollie Smith.)

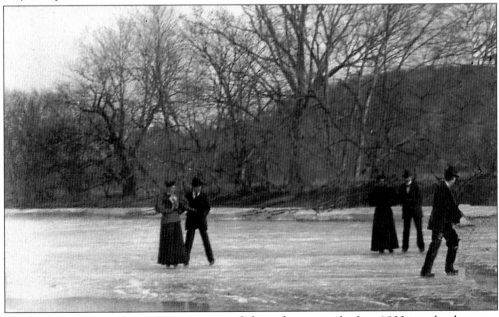

Ice-skating was a popular winter pastime, and these skaters, in the late 1800s, took advantage of the extremely cold weather that froze the water in the first dam. The water from the Spring Field dams provided the power for Antrim Mill. This is a photograph from one of the George F. Ziegler glass-plate negatives. (Courtesy of the Allison-Antrim Museum.)

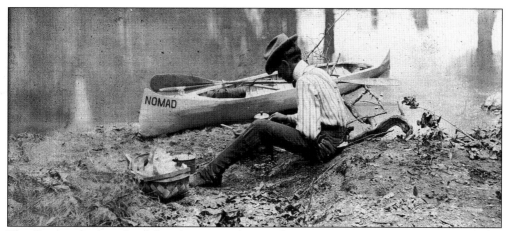

The Conococheague Creek has drawn people to it for many reasons since settlers first arrived here. One of the later reasons was recreation. On a summer day, the Conococheague was the perfect place to leisurely canoe down the creek, fish, or swim in one of the favorite swimming holes. George F. Ziegler took this photograph at the turn of the 20th century. (Courtesy of the Allison-Antrim Museum.)

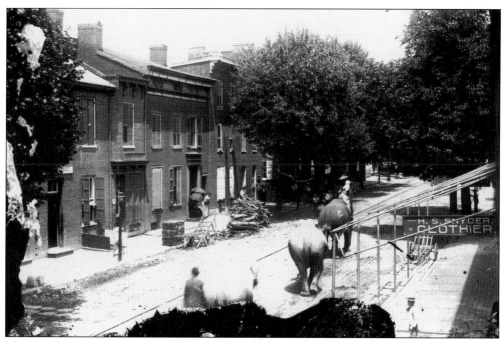

The day the circus came to town, elephants could be seen walking up North Carlisle Street. It was probably more common then than now because small circus companies were a popular form of entertainment in the late 1800s. The troupes traveled between small towns, giving delight to all. George F. Ziegler had his camera ready for an opportune shot. (Courtesy of the Allison-Antrim Museum.)

The Greencastle Travelers Club, organized in the late 1800s, met in private homes to talk about travel through the sharing of the members' own experiences. This group may have evolved out of the Diagnothian Literary Society since books were also discussed. Some ladies from town who were members were Sidney and Mary Nill, Daisy Gillan, Drucilla Kress, Frances Davison, Lillian Ruthrauff, Elisabeth Brumbaugh, and Anne Grove. (Courtesy of the Lilian S. Besore Memorial Library.)

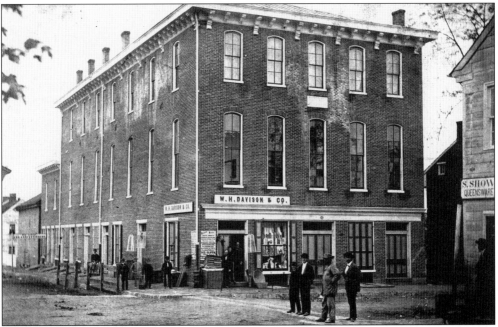

Town hall was built in 1871. The lower floor accommodated businesses, and the second floor auditorium (special events center) provided an area for band concerts, plays, lectures, and dances. The Grand Army of the Republic met on the third floor, along with fraternal organizations. Town hall closed for entertainment purposes in 1913 because of competition from the McLaughlin Hotel's new Gem Theater. This photograph was taken between 1871 and 1875. (Courtesy of the Lilian S. Besore Memorial Library.)

Young people have always enjoyed socializing with their friends when they are not attending school or working. Clary's Ice Cream Shop at 15 Center Square provided the ideal place to go c. 1900. The ice cream shop was located at the back of Clary's Bakery. Seen here, from left to right, are Clayton Phipps, Henrietta Brown, and two unidentified people. (Courtesy of the Lilian S. Besore Memorial Library.)

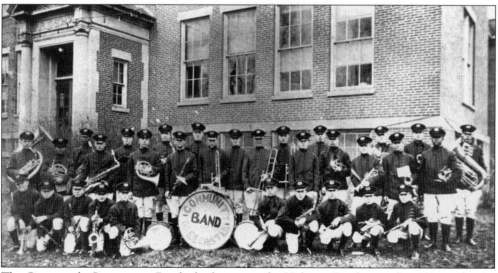

The Greencastle Community Band, also known as the Holstein Band, started in 1921 under the sponsorship of the Greencastle Board of Trade. The band was directed by George Lewis, a self-taught musician who had his own small band. The integration of the band prompted its nickname, "Holstein." For six years, the band, with many of its members taught by Lewis, performed in parades and at other functions. (Courtesy of the Lilian S. Besore Memorial Library.)

Harry McLaughlin built an annex onto his hotel c. 1912 that housed a movie theater for a number of years. The entrance was very ornate, with sculptured cherubs and great architectural details. The first manager was David B. Cump. The movie sideboards announce three features in November: *The House of Bondage; Brothers;* and *The Love Trail.* A ticket at the Gem Theater cost 5¢ for children and 10¢ for adults. (Courtesy of Ollie Smith.)

Participating in the annual community Fourth of July children's parade, William P. Conrad (left) is dressed as Uncle Sam, and Jake Teeter (right) is dressed as Lady Liberty. This photograph was taken in 1914, when the young lads were about four years old. The children's parade was revived in 2003 at the new annual Greencastle-Antrim Fourth of July celebration. (Courtesy of Nan Conrad Flaherty.)

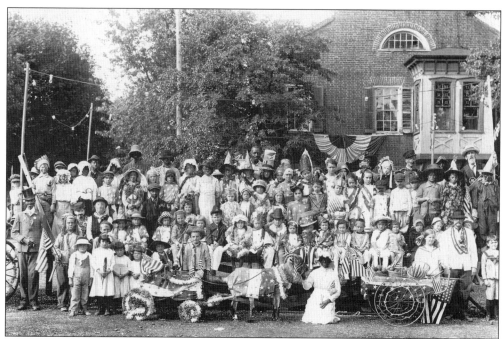

The children of the Greencastle-Antrim community gather together on the grandstand for a photograph at the annual Fourth of July parade in 1914. Many are dressed in patriotic costumes of stars and stripes and are holding flags. A patriotic goat is hitched to a decorated wagon. William Conrad and Jake Teeter can be seen sitting just behind the nose of the goat. (Courtesy of Jean Oliver Reymer and Robert C. Reymer Jr.)

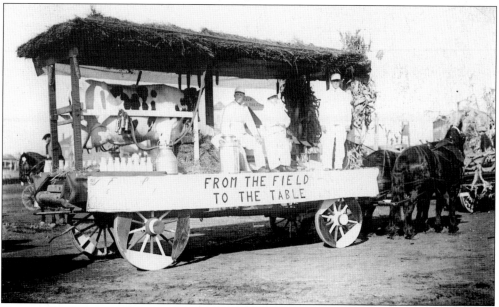

Greencastle-Antrim held a parade *c.* 1925 celebrating the bounty of the township at harvest time. "From the Field to the Table," a horse-drawn wagon float, showcased a Holstein cow, modern milking equipment, and the fresh bottles of milk that were delivered to every home each morning by the milkman. (Courtesy of Jean Oliver Reymer and Robert C. Reymer Jr.)

111

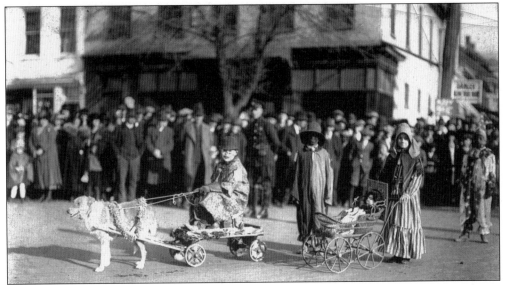

Frances Walck Kefauver, the namesake of Lt. Col. B. F. Winger's daughter Frances, is shown with the doll carriage that belonged to Frances Winger Davison when she was a little girl. The doll carriage, 130 years old, is exhibited at the Allison-Antrim Museum. Frances Walck Kefauver's cousin Ralph Ziegler rides on the wagon that his dog is hitched to. (Courtesy of the Allison-Antrim Museum.)

Appearing in this 1938 photograph, from left to right, are Glenn Hicks, Alvin Hicks, and Lauren Myers, with their string instruments ready to play some good old-time music. Small groups of people got together to play music just for fun and self-entertainment. For a while during the 1920s, Alvin played live on Baltimore's WFBR radio station every Saturday night. (Courtesy of Kermit Hicks.)

The Rescue Hose Company's minstrel shows, used as fund-raisers, began in February 1929. The productions were held in the Gem Theater until the Greencastle Elementary building and auditorium were built on South Washington Street. This event—which abandoned the blackface tradition many years ago—remains one of the oldest ongoing minstrel shows in the nation. From left to right are Betty Jane Shatzer, Jake Teeter, Vic Martin, Sambo Mowen, and Bobby Holbert. (Courtesy of Rescue Hose Company.)

Either in the fall of 1948 or the spring of 1949, the Junior Sportsman Association was formed by Lloyd "Tuck" McDonald as a way to get the young men of the area involved in the Greencastle Sportsman Association. Those shown here at one of the group's first outings on April 3, 1949, are the charter members. Tuck McDonald stands on the far right. (Courtesy of Lloyd "Toby" McDonald Jr.)

One of the best dining places in the area during the late 1940s into the 1950s was the McLaughlin Hotel's Palomino Room. It was so named because of the palomino horses that manager Bill McLaughlin kept stabled in the Antrim House livery stables. The Waynesboro Library Great Books Society, shown here, occasionally met at the Palomino Room for dinner. This photograph was taken on May 29, 1949, by Sylvester Snyder. (Courtesy of the Allison-Antrim Museum.)

Before World War I, Greencastle had produced three major-league baseball players: Albert Goetz, Charles Reno "Togie" Pittenger, and Charles "King" Lear. The Sunday School League, formed in 1921, consisted of six teams from the following churches: Trinity Lutheran, Evangelical Lutheran, Methodist, Presbyterian, Reformed, and United Brethren. The members of this Trinity Lutheran team are unidentified. (Courtesy of Lloyd "Sonny" Rowe.)

The Greencastle Athletic Club was an all-star team that evolved out of the Sunday School League, which was active between 1921 and 1923. The athletic club was part of the Blue Ridge Baseball League and played against teams from other towns in the valley. The club's home games were all played at the Jerome R. King Playground from 1923 onward. This photograph was taken c. 1925. (Courtesy of Patti Muck.)

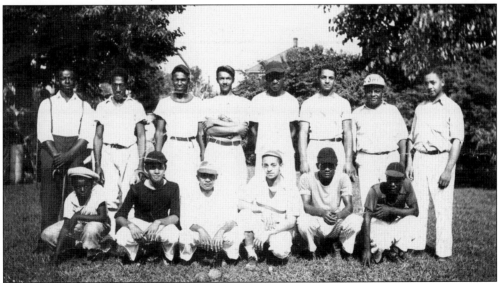

Jack Dixon, one of the town's barbers, formed a team of softball players called Jack's Giants (pronounced "Gints"). The team was not part of a league and is the only known African American sports team to have existed in Greencastle-Antrim. Games were played against other teams in town. A following of loyal fans filled the stands at King Playground, where the Giants games were always played. (Courtesy of Jackie Dixon.)

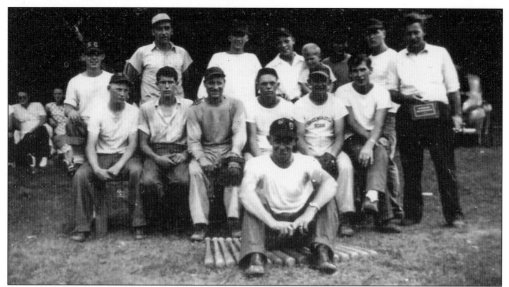

This *c.* 1948 photograph of the Shady Grove Baseball Team predates the team joining the Franklin County League. The team's ball field was in Gerald Gearhart's meadow just south of Route 16, between the trolley tracks and Gearhart Road. The games were played every Sunday afternoon between the cow piles. (Courtesy of the Shady Grove Community Center.)

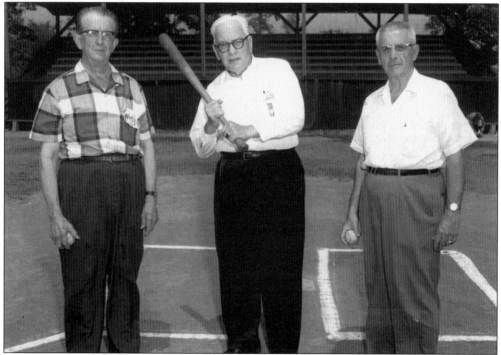

Pictured during Old Home Week in 1965, Perkins "Si" Glass (center) of the Presbyterian team holds the bat that he used to hit the first home run at Jerome R. King Playground on August 14, 1923, during a Sunday School League game. With him on the left is James Craig Sr., the Presbyterian team pitcher, and on the right is Sam Brewbaker, the Methodist team pitcher who threw the home-run ball. (Courtesy of James H. Craig Jr.)

Ten
OLD HOME WEEK

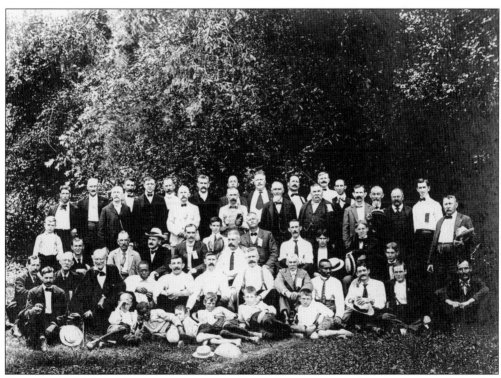

Sixty-five "Old Boys" from many towns in Pennsylvania and neighboring states returned to their hometown of Greencastle for a 10-day Old Boys Reunion on August 10–20, 1902. In 1905, the "Old Girls" of Greencastle were also invited, at which time the celebration became known as Old Home Week. The year 1908 marked the inclusion of the sons and daughters of Antrim Township in the triennial celebration. (Courtesy of the Allison-Antrim Museum.)

Philip Edward Baer was the founder of Greencastle-Antrim's beloved Old Home Week triennial celebration. Professor Baer became a nationally known opera singer after studying voice, opera, violin, piano, and Italian for four years in Italy. While on tour, he often visited with old friends from Greencastle who came to his concerts. The seed for Old Home Week was planted during these special times of reminiscing. (Courtesy of the Allison-Antrim Museum.)

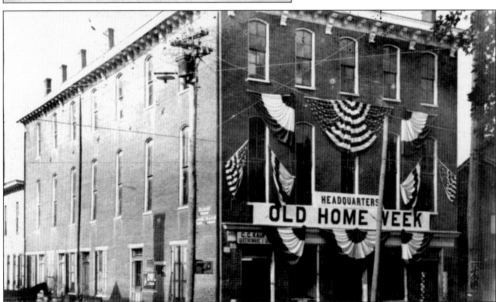

Town hall, at the corner of South Washington and East Baltimore Streets, served as Old Home Week headquarters from 1902 through 1911. In 1902, the town hall facility provided accommodations for a chicken dinner for the Old Boys, and by 1911, it hosted a reception, a smoker, a firemen's reunion, and dramatic presentations. (Courtesy of the Lilian S. Besore Memorial Library.)

Sandy Hollow, an area along the west bank of the Conococheague Creek a mile west of town, was a favorite place for swimming since the settlers arrived in Antrim. This cool, shady spot was chosen for a picnic during the first Old Boys Reunion, and it was here that the first reunion photograph was taken. The Old Home Week photograph has been a tradition ever since. (Courtesy of the Lilian S. Besore Memorial Library.)

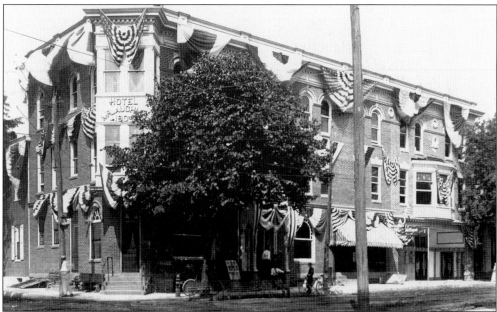

The McLaughlin Hotel was a favorite place to stay during Old Home Week. Constructed in 1904 by Harry McLaughlin, it was the most modern of the hostelries at the turn of the century. Accommodations included central heat, a grand lobby, a dining room, an ice-cream parlor, a bar, and a billiards and pool parlor. Each floor had a central bathroom, and each room had running water. (Courtesy of the Lilian S. Besore Memorial Library.)

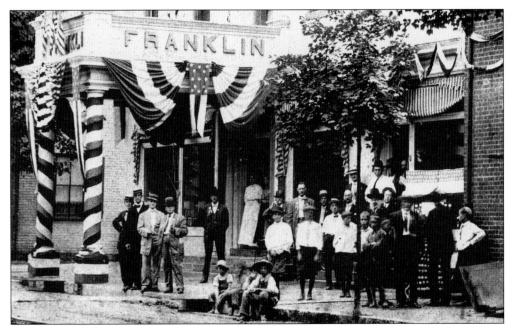

The Franklin House at 11 North Carlisle Street was another popular lodging place for out-of-town guests. From 1902 to 1908, the passenger station was only one-half block north of the Franklin House, quite convenient for the visiting Old Boys and Old Girls. The guests in this 1911 photograph were shuttled from the new "high line" station by a horse-drawn vehicle and dropped off at the new portico. (Courtesy of Lloyd "Sonny" Rowe.)

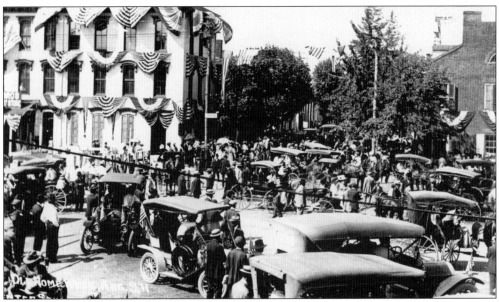

Being in the center of town made the square a natural place for people to congregate. Over the past century of Old Home Weeks, many events have taken place in the square. The antique car show is a favorite event that is held on Sunday. This 1911 photograph shows one of the first car shows, though at the time the cars were not antiques. (Courtesy of the Lilian S. Besore Memorial Library.)

The first gift presented to the community during the 1914 Old Home Week was the granite drinking fountain from a group of Old Boys. In 1922, David D. King, a Chicago businessman, purchased and donated a five-acre plot of land, which was named for his deceased brother Jerome R. King. It was to be "used as a public recreation ground for the people of Greencastle." For Old Home Week 1923, King chartered a train from Chicago carrying 125 former Greencastle-Antrim residents to Greencastle for the dedication ceremonies on August 6. This photograph, taken from Fleming Hill, shows the area as it looked before the five-acre plot along North Carlisle Street belonging to Abram K. Carbaugh was bought for the playground. Some landmarks are the Evangelical Lutheran Church steeple, town hall, and the town clock. (Courtesy of Lloyd "Sonny" Rowe.)

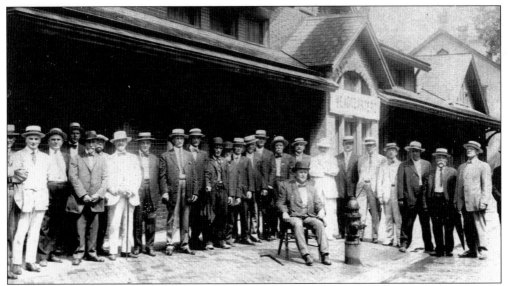

Philip Baer sits in a place of honor as the founder of Old Home Week in 1914 in front of the old Cumberland Valley Railroad passenger station at 100 North Carlisle Street. At this time, the former station was being used as a temporary classroom for high school students while a new school building was constructed on South Washington Street. (Courtesy of Travel Centers of America.)

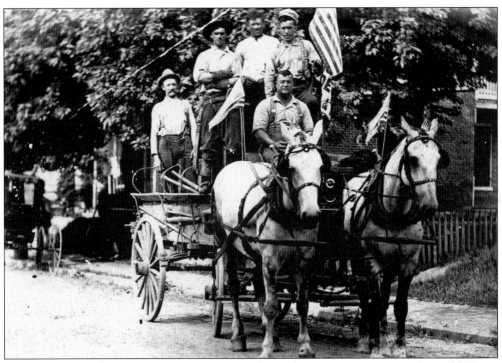

The United Telephone Company linemen in a horse-drawn wagon are part of an Old Home Week parade. They worked in the Greencastle-Waynesboro area. From left to right are Charles Laubs, Ben Sease, George Helman, and Walter Diffenbaugh. Max Lesher is the driver of the wagon. (Courtesy of Ollie Smith.)

In 1938, the Old Home Week pageant was introduced into the program of events. The pageant was written by G. Fred Ziegler, editor of the *Echo Pilot*. Each scene told the story of a special historical event in Greencastle-Antrim. As it still is today, the pageant was presented on Tuesday and Wednesday evenings. Wednesday, August 6, 1941, was the date of this Colonial-era scene. (Courtesy of Evelyn Pensinger.)

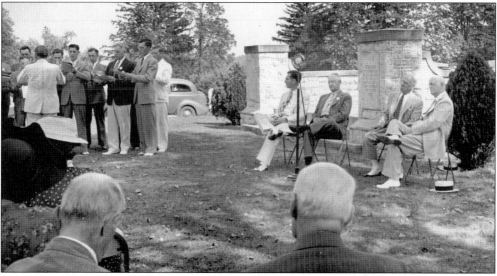

A memorial service and opening ceremonies for the 1941 Old Home Week took place on Sunday, August 3, at the Cedar Hill Cemetery. Seated, from left to right, are Charles W. Bert, Rev. Charles M. Mickley, Dr. Charles W. Brewbaker, and the Honorable Watson R. Davison. They listen as the Pan Pipers Glee Club sings. (Courtesy of Evelyn Pensinger.)

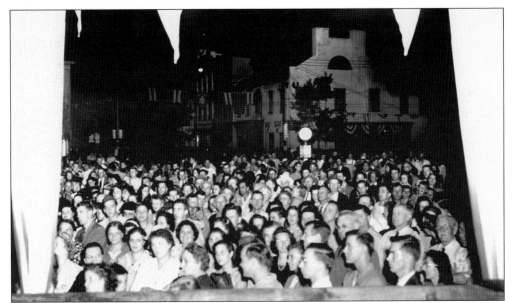

The unofficial Old Home Week opening is held on the square on Sunday at midnight. Before the town clock strikes midnight, music is provided, old-time songs are sung, and the reuniting of old acquaintances occurs once again. Here, the crowd, including youngsters, packs the square on Sunday, August 3, 1941, in anticipation of the clock striking 12 and the singing of "The Old Gray Mare." (Courtesy of Evelyn Pensinger.)

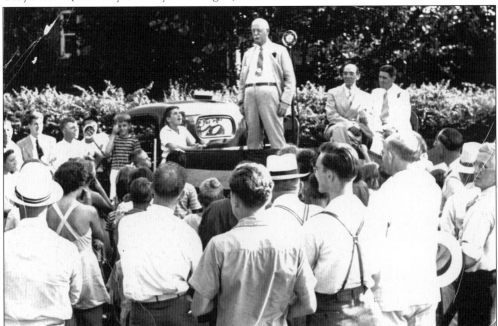

Franklin County Judge Watson Rowe Davison gives the dedication speech for the King sundial from the bed of a pickup truck in 1941. Seated behind Judge Davison are Benjamin S. Whitmore (left), a well-respected educator, and Joshua E. Oliver (right), a partner in Omwake and Oliver and president of the King Playground Association. (Courtesy of Jean Oliver Reymer and Robert C. Reymer Jr.)

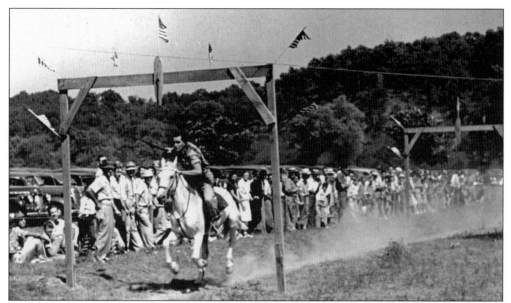

On Friday, August 8, 1941, in front of a big crowd, a jousting tournament was held in Myers's Meadow. The meadow was on the south side of old Route 16 leading to the five-arch bridge over the Conococheague Creek. Paul Seacrist, seen in this photograph, won first prize in the beginner's class. This was the first and last time this event was held during Old Home Week. (Courtesy of Evelyn Pensinger.)

One of the first places Old Home Week visitors go when they arrive in Greencastle is headquarters. The first Old Home Week committee person to greet them there is the registrar, who can answer most any question about the upcoming events. Jessie Ruthrauff Shrader, registrar from 1947 to 1965, watches as Florence Richardson signs herself and her daughters in the official 1959 registry book. (Courtesy of the *Record Herald*.)

Following Jessie Shrader as registrar for Old Home Week was Kathleen "Katty" Grosh, who knew each person by name when he or she walked into headquarters, whether they were from the town or township or had not been back to Greencastle in years. Grosh served as registrar from 1968 to 1992 and, prior to that, was assistant registrar to Jessie Shrader. (Courtesy of Kenneth Shockey.)

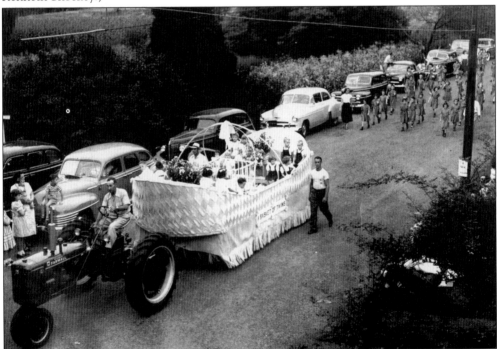

In the 1950 Old Home Week parade, "A Basket of Twins" was entered as one of the floats for judging. The bassinet with a playpen has six sets of twins riding in it. Not far behind the float are the local Girl Scouts. It is hard to believe that the borough parade route included such a rural setting in 1950. (Courtesy of Evelyn Pensinger.)

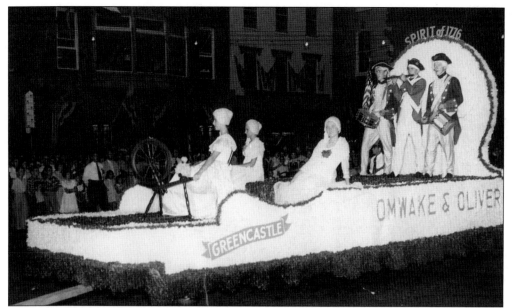

Omwake and Oliver's float entry in the 1950 or 1953 Old Home Week parade celebrated the "Spirit of 1776." At the back of the float is James P. Oliver (left) portraying a drummer from the Revolutionary War. The float has just entered the square from North Carlisle Street. The First National Bank is behind the back of the float. (Courtesy of Jean Oliver Reymer and Robert C. Reymer Jr.)

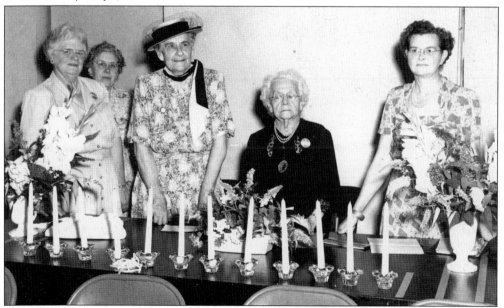

The Loyal Daughters organization was founded in 1920. Its purpose is to honor fore-fathers and -mothers through charitable contributions to the community. Throughout the years, the group has underwritten the electrifying of the town clock and has made donations to support the public and school libraries, among other service projects. The Loyal Daughters memorial service, which honors deceased members, is about to begin during Old Home Week 1950. (Courtesy of Frank H. Ervin.)

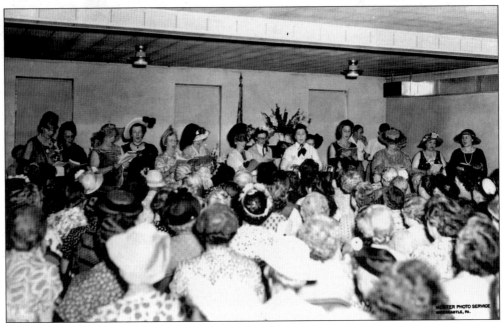

This sea of chapeaus was seen during an Old Home Week in the 1940s in the community room of the Citizens Bank. The Senior Women's Club was singing during the program portion of the triennial Loyal Daughters meeting, held on Tuesday of each Old Home Week. Photographs of the Loyal Daughters' gatherings are rare, and only a few men have ever been in attendance as guests. (Courtesy of Isabelle Barnes.)

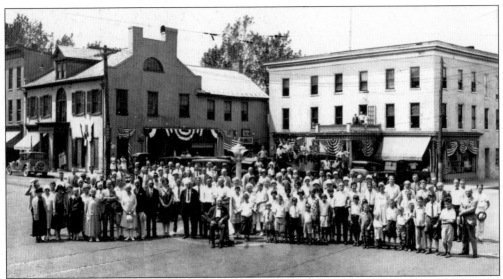

The 1929 Old Home Week was the 10th triennial. It was a time of prosperity shortly before the stock market crashed in October. By this time, triennial events such as the Old Home Week photograph, parade, and fireworks had become traditions. Returning home for the festivities, renewing acquaintances, and reminiscing have strengthened Greencastle-Antrim's connection to its past for more than 100 years, helping roots grow deeper for future generations. (Courtesy of P. Sean Guy.)